ARTHUR RANSOME

on the

BROADS

ROGER WARDALE

AMBERLEY

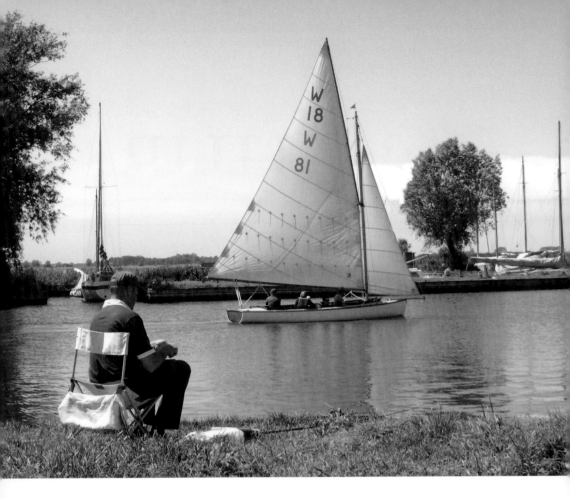

First published 2013

Amberley Publishing
The Hill, Stroud
Gloucestershire, GL5 4EP

www.amberley-books.com

British Library Cataloguing in Publication Data.
A catalogue record for this book is available from the British Library.

ISBN 978 1 4456 1152 5

Typeset in 10pt on 12pt Sabon.
Typesetting and Origination by Amberley Publishing.
Printed in the UK.

Contents

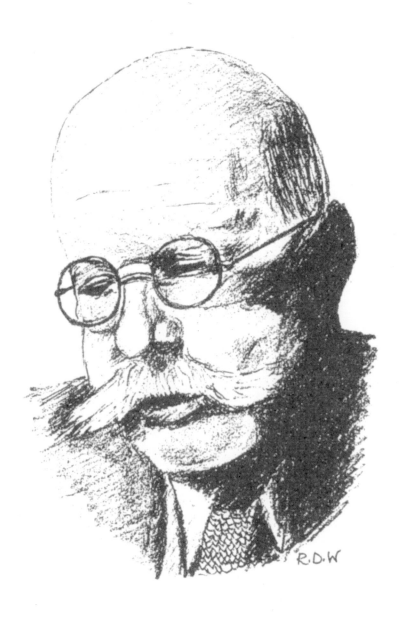

Arthur Ransome
From a photograph.

'Snatches from a Dozen Different Lives'

Arthur Ransome was born in 1884, the eldest child of an academic middle-class Yorkshire family. His father was a country-loving professor of history and his wife, also a historian, was an accomplished amateur watercolourist. Later in his life he recalled his great pleasure at listening to her reading aloud. She made a point of choosing only those books that she herself enjoyed, so that the children were introduced to literature at an early age and she was careful to see that their own reading matter should be only the best. Significantly, the young Arthur collected all Andrew Lang's fairytale books, read *Robinson Crusoe* at about the age of four and wrote a short story about a desert island when he was seven.

On his father's side there were a number of Quakers. His grandfather was a fascinating companion for a small boy on the country walks that they took from their home in the northern suburbs of Leeds, and as a consequence he developed a lifelong interest in natural history. Both his father and grandfather were enthusiastic fishermen who shared a special affection for the River Beela in Lancashire and years later Ransome found a special satisfaction in fishing the river in his turn.

On his mother's side, his grandfather was a wealthy Australian sheep farmer and one of that country's foremost artists, who fathered eighteen children in two families, one in Australia and the other in England. Arthur's mother was the eldest child of his second family. From his home in Clifton his grandfather took Arthur around the Bristol Docks to see the sailing ships tied up alongside the quays that he had read about in *Treasure Island*.

Not all Ransome's paternal forbears were northerners; he claimed that one of his ancestors was a sixteenth-century miller in North Walsham. In 1789 Robert Ransome left Manchester to found the Ipswich firm of agricultural implement and lawnmower manufacturers that became the major company that bore his name.

Those things that enriched his life – or as he put it, snatches of a dozen different lives – love of literature, writing, fishing, boats and the natural world were acquired when he was small.

Above all, he inherited his father's love of the Lake District. At the start of the long vacation the family packed up and headed for a farm close to the foot of Coniston Water. Their holiday home allowed his father to fish the river and nearby lake in fine weather and attend to the writing of history textbooks when it rained. The farm was at the foot of the fells at the head of the Crake Valley. The children made friends with the farm animals and the local lake country folk. Best of all were those days when his father took them

all up the lake to Peel Island, rowed off to fish while his mother sketched, allowing the children spent the day 'as savages'. His emotional attachment to the area began when he was quite young. Almost forty years later those long, idyllic summer holidays were to become the springboard for the writing of *Swallows and Amazons*.

Then came the time for Arthur to go to a muscular prep school in Windermere where he tried unsuccessfully to fit in. As intensely wretched as only a misfit can be, his life was only made bearable by his weekly visit for Sunday lunch with Great Aunt Susan, who lived nearby.

Just after it had been revealed that Arthur had failed miserably to gain a scholarship to Rugby, his father's old school, he received the news of the death of his father from complications resulting from a fall while fishing at night in the River Crake. He just managed to scrape into Rugby and his poor showing turned out to be a blessing in disguise, as he came under the wing of Dr W. H. D. Rouse, a great classical scholar with a regard for English literature that he taught in school. He soon recognised and encouraged Arthur's ambition to become a writer. This dismayed the newly widowed Mrs Ransome, who correctly foresaw writing as a precarious way of making a living.

Rather than accept Rouse's offer of coaching for Oxford entrance, Arthur dutifully enrolled at the Yorkshire College where his father had taught, and began to study science. A scientific career was not to be. Ransome's university career lasted little more than one term and came to an end after he had read the *Life of William Morris*. He was entranced by 'the lives of young William Morris and his friends, of lives in which nothing seemed to matter except the making of lovely things and the making of a world to match them'. He spent his time at university 'writing and reading, reading and writing' rather than among test tubes and Bunsen burners, and in February 1902, when he was just eighteen and with his mother's blessing, he took a job as office boy in a London publishers. Very sensibly, his mother also moved to London in order to keep some sort of eye on him while he still lived at home, and also to enable her elder daughter Cecily, who had ambitions of becoming an artist, to set up a studio.

The errand boy job lasted six months before Ransome sought more suitable employment, work that would give him more time for his writing, and he joined the struggling Unicorn Press. A year later, having had some little pieces published, he resigned in order to devote himself to writing, and not very long after that he left the family home in south London and took lodgings in Chelsea. Mrs Ransome's worst fears were about to be realised.

Support for his embryonic career as a writer came from a Lake District acquaintance of his father. This was W. G. Collingwood, the Norse scholar, artist and writer who lived at Coniston and who came upon him lying on a rock in the middle of a mountain beck composing poetry. The Collingwoods became a hugely influential second family and he would head north to visit them on his annual holiday for the next few years.

Ransome rejoiced in the company of a dashing set of poets, artists and writers, hobnobbing with John Masefield, Gordon Bottomley, Edward Thomas, Lascelles Abercrombie, W. B. Yeats, the Jamaican artist Pixie Coleman Smith and the Chestertons. He sang shanties with Masefield, drank a mixture of claret diluted with fizzy lemonade with Yeats, shared rooms with Thomas and was entranced by the stories of Anansi, the

big fat shiny spider, as told by Pixie Coleman Smith; stories that he would himself retell many times.

There was a price to be paid for his new-found independence, for most of what little money was coming in was spent on books. There were many times when he fed poorly, although in his autobiography he tells with relish how he made a good meal out of a haddock that would last twenty-four hours. That was on good days. At other times he existed on a diet of apples and cheese. As a result of these privations and his poor diet during his early days in Russia, Ransome suffered from chronic stomach problems for the rest of his life.

His own writing progressed from early ghost-writing to collections of his stories and essays – *The Souls of the Streets*, a slim volume of stories and articles in 1904, *The Stone Lady*, containing 'Ten Little Papers and Two Mad Stories', in 1905 and three little nature books for children in 1906. These are earnest little books and very well-intentioned.

The Collingwood family gave Ransome more than support and encouragement, for they had two very eligible daughters. Dora and Barbara were artistic, intelligent and refined, qualities certain to appeal to an impressionable young man. He fell happily in love, first with Barbara and then with Dora, but both in their turn refused his proposal of marriage. Ransome, at the age of twenty-one or so, was an appealing, boisterous, enthusiastic schoolboy, stimulating company but not one, perhaps, to be taken seriously. Utterly at home in bohemian London in the years before the First World War, Ransome recorded it for posterity in *Bohemia in London*, published in 1907, a book that is both immature and pretentious.

At this point the literary novice became a critic and began the series, 'The World's Storytellers' and this in turn led to *A History of Storytelling*. While he was compiling it he stumbled into his first marriage. After his rejection by the Collingwood sisters, he had developed the habit of making proposals of marriage 'for practice'. Unhappily for both parties, the wrong young woman accepted him. Like many young men starting out, Ransome had succumbed to the attractions of the capital but by the time of their marriage he was ready to settle in the country, although not ready for the give and take of married life. In the next two years the Ransomes were to move seven times before settling into Manor Farmhouse, a mile from the village of Hatch in Wiltshire. Meanwhile their daughter, Tabitha, was born.

There were faults on both sides. Ransome was frequently away from home, or dashing off to fish or play billiards when he returned. His wife, Ivy, who was accustomed to plenty of attention, was unhappy at these frequent absences and had a habit of throwing a tantrum when she could not get her own way.

It was against this background of a failing marriage that Ransome was commissioned to write a critical study of Oscar Wilde. Once published it landed him in the High Court, sued by Lord Alfred Douglas who claimed that Ransome had suggested that he was responsible for Wilde's downfall. After twelve months of suspense and a nightmare of a trial in the spring of 1913, the jury found in Ransome's favour. Ivy had flourished in the spotlight of the trial, being the only woman to remain in the courtroom, but Ransome hated it.

The whole sordid affair hardened his resolve to distance himself both from Ivy and the aftermath of the trial. He secretly secured a passport, led Ivy to believe he was just off for a few days, scribbled a note to his mother at the dockside and took a boat for Copenhagen.

He still hankered after writing stories for children, and he saw in the many Russian folk tales ready-made stories that when translated would provide the basis for a jolly little book, but first he had to learn the language. A friend arranged an introduction to an Anglo-Russian family of timber merchants who lived a few miles inside the Finnish border. From here Ransome began his Russian studies.

In the autumn he was back in England in an unsuccessful attempt to save his marriage and by the time he left for Russia in April 1914, armed with a commission to write a guide to St Petersburg, it had become clear that it had deteriorated beyond repair. In a frenzy of exploration by day and pounding at his typewriter of an evening Ransome completed the guide in a couple of months and had become intimate with the byways of the city.

When Europe was plunged into war Ransome made his way back to England. At first he was unable to find a place in the scheme of things. His brother Geoffrey had joined up, but he had no stomach for the fight, and as the newspapers had already sent their correspondents to Russia he started on his Russian fairy stories. By the end of 1914 he was able to return to St Petersburg with a contract for his new book. Ransome spent some months at the Vergezha family estate in the country working on *Old Peter's Russian Tales* and suffering with piles and stomach ulcers. Finally, his doctors advised an operation. He was recovering from this and was 'fit for nowt' when Harold Williams, *The Times'* correspondent in St Petersburg, who believed that Ransome had the making of a good journalist, arranged for him to deputise for the correspondent of the *Daily News*, and when he returned to England to complete his convalescence the newspaper confirmed his status as their official Russian correspondent.

Much has been written in recent years about Ransome's time in Russia: how he reported on the military disasters and watched the civil unrest that led to the Revolution in 1917 when he came under fire; how he became acquainted with the leading revolutionaries and met his second wife, Evgenia, when she was working as Leon Trotsky's personal assistant and how eventually he became closer to the Bolshevik leaders than any other western commentator.

His reports of events as he saw them were met with hostility in England and gave the Foreign Office and the Intelligence Services severe problems throughout his time in Eastern Europe. On the one hand Special Branch came close to arresting him for treason and MI5 kept an eye on his letters home; on the other, MI6 recruited him as Agent S76 in September 1918. Did he do any covert investigation? Probably not. For their part, the Bolshevik leaders found him a most useful ally; somebody with a voice in the West who would present them in the best possible light, and who would also be able to let them know the way things were viewed in Britain. Ransome was no exile during his early years in Russia; he made regular visits to England, visiting the Collingwoods and his mother and doing a little fishing.

Old Peter's Russian Tales is set in Czarist Russia, a world away from the conflict between the White Russians and the Red Army taking place in 1918. By this time,

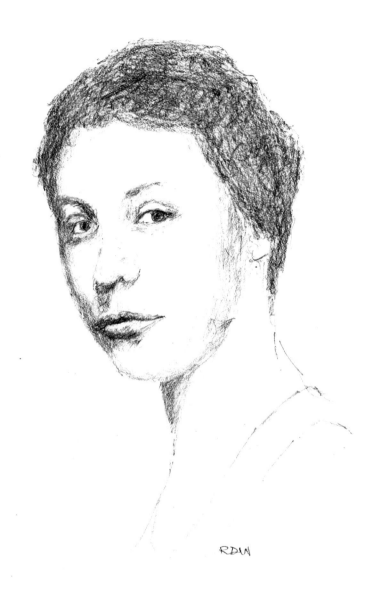

RDW

Evgenia
From a photograph taken around the time of their first Broads holiday in 1931.

Evgenia and he were an item and each made their separate way out of Russia to be reunited in neutral Stockholm, from where he continued to send telegrams to the *Daily News*. Anti-Bolshevik forces were at work in Sweden and both he and Evgenia were expelled and returned to Russia.

Leaving Evgenia in Moscow, Ransome set off for England in March 1919 to see if he could persuade Ivy to agree to a divorce. On arrival, after more than a year away, he was immediately interrogated by Special Branch. He convinced them that he was harmless and had come home to enjoy some fishing. On earlier visits he had visited Oulton Broad, where he went pike fishing with Dora Collingwood's Anglo-Armenian husband Ernest Altounyan. In a draft for his autobiography Ransome wrote, 'I had known the Broads in the far away past when, in an ancient wherry, I had gone fishing for pike there in the late autumn after all the pleasure craft of those days had been pulled out to winter in their sheds.'

Ivy proved intransigent, and when he was unable to arrange for Evgenia to come to England, he managed to return to Moscow via Estonia where he was entrusted with a message that the country was ready to open peace negotiations with the Bolsheviks. Crossing No Man's Land between the warring armies proved a hazardous undertaking, but by the end of October 1919, Ransome had delivered his message and been reunited with Evgenia.

Shortly afterwards he returned to Reval in Estonia with Evgenia and the Bolshevik offer of an armistice. Papers had been provided that would see 'Mr and Mrs Ransome' through the Russian lines but thereafter they had to make their own hazardous way. Before they left Moscow, Evgenia collected thirty-two diamonds and three strings of pearls destined for England. Was their safe delivery into the hands of Soviet agents in Estonia the price Evgenia paid for their escape?

Once they were safe, Ransome promptly collapsed with the strain of it all. He was now Russian correspondent for the *Manchester Guardian*. They lived in Reval for over a year before moving to Riga in Latvia where they remained until Ivy finally agreed to a divorce in 1924 and they were able to marry.

They had made an abortive attempt to return to England in 1921 and Ransome's mother found them a cottage near the Broads in which to set up home, but in the event they decided not to return to England until they were man and wife. During their four years in Eastern Europe Ransome made occasional forays into Russia and visited England to see family and friends and to make various attempts to prise a divorce out of Ivy.

The *Manchester Guardian* saw to it that their special correspondent earned his salary but that did not prevent him doing some sailing. He had been taught to sail by Robin Collingwood, who had introduced him to the delights of small boats in those heady Coniston holidays before he was married.

After coastal trips in small yachts, he was able to build his dream ship in the winter of 1921/2. This was a sturdy, 30-foot ketch that they named *Racundra*. Its principle feature was its vast cabin, 10 feet square. In *Racundra* they had a leisurely ten-week cruise across the Baltic among the islands in the late summer of 1922, taking time out to spend a month in Reval where Evgenia remained while Ransome and his crew crossed to Helsinki. His subsequent book *Racundra's First Cruise* became a classic

among sailing memoirs and some have seen it as the forerunner of *Swallows and Amazons*. The following year they had planned a cruise among the Finnish islands but he had an urgent recall to England to consult his lawyer about his divorce.

Once they were married in the summer of 1924, the 'Master and Owner of *Racundra*' and 'The Cook' had a gentle, six-week 'honeymoon voyage' up the Dvina and Aa rivers from Riga where they left their dream ship when they sailed for England.

Their first Lake District home was a sturdy whitewashed cottage among the hills to the south of Bowness-on-Windermere. The property included a stone barn a few feet from the cottage that they converted into a spacious workroom with a spectacular view across the valley towards distant Yorkshire.

During the next few years the *Manchester Guardian* sent Ransome to places as far-flung as Sudan and China whenever the political situation in that country required investigation – visits that he made with greater and greater reluctance. His regular column in the paper was much more appealing. Entitled 'Rod and Line', the weekly fishing column gave him both opportunity and reason to fish widely. The essays had a distinctly northern flavour and because many were leavened with gentle humour and witty observation they also appealed to those who had never fished.

Ransome did not claim to be a good fisherman (although he undoubtedly was) or that he had caught any particularly notable fish, rather that he thoroughly enjoyed all aspects of the sport, finding particular pleasure from catching fish on flies of his own creation. It seems surprising that in more than 150 articles, Ransome has practically nothing to say about fishing on the Broads.

When the *Manchester Guardian* offered Ransome the opportunity to take over its prestigious back-page 'Saturday Article', he brought the series to an end without any regrets. Entitled 'Drawn at a Venture', he was now free to choose his own topic every week and early titles included 'On Sitting Down to Think', 'Those So-Called Fairies' and 'Dressing Up'.

At Christmas 1928 Ransome wrote to his mother regretting that he had no new book to send her. By this he meant a storybook, as the forthcoming *Rod and Line* collection, containing fifty of the *Manchester Guardian* essays, hardly counted. He had become more and more entrapped in the world of journalism and then, by one of those twists of fate, his life was changed by the gift of a pair of slippers.

Dora and Ernest Altounyan had left Aleppo in Syria where they lived, and returned to Dora's old home at Coniston, as her mother was close to death. Eventually they stayed for nine months and Altounyan bought two small dinghies for the four eldest children who were aged six to eleven. The story goes that it was agreed that at the end of the summer one of the dinghies would become Ransome's, and in October the *Swallow* joined her new owner on Windermere.

When the time came for their return to Aleppo the following January two of the children arrived at the cottage with a magnificent pair of red leather slippers that they had brought for him from Syria as a late birthday present. Angry at first at being disturbed, he was greatly touched by their gift. Sailing in the *Swallow* a couple of months later he made up his mind to return their gift by writing a book for them.

The result was *Swallows and Amazons*, which overcame the disadvantage of its obscure title to enjoy massive sales since its publication in 1930 and translation (so far) into thirty-six languages.

John, Susan, Titty and Roger Walker set off in a borrowed sailing dinghy, *Swallow*, and camp on Wild Cat Island. They make war and then peace with a couple of local Amazon pirates, Nancy and Peggy Blackett, who live some distance up the lake at Beckfoot. During the Swallows' night attack on the Amazons' stronghold Titty overhears burglars burying treasure on one of the islands. They make peace and then war with Captain Flint, in reality the Amazons' uncle, and after they recover the 'treasure', they discover that it contains the book that he has been writing. The book ends with the promise of more adventures the following summer holidays.

As he was starting to write, it became clear that the *Manchester Guardian* still regarded him as a political journalist for they asked him to go to Berlin as their correspondent. With the full support of Evgenia, Ransome gave three months' notice. After July 1929 they would have to exist on freelance work – book reviewing, the occasional political article and what he could earn by writing stories.

The writing of *Swallows and Amazons* came easily, 'It almost wrote itself', he remarked. Even so the book nearly foundered amid the weekly grind of churning out the Saturday articles. Only a trip to Egypt to report on the elections in December 1929, during which he fell ill, gave him the respite needed to forge ahead sufficiently to be able to complete the book when he returned to England in the New Year.

The Altounyans were delighted with their present, especially as three of the Swallows bore their names in order that they could imagine the adventures to be their own. The imaginative Titty, for whom Windermere becomes 'a desolate ocean sailed for the first time by white seamen', enriches the Swallows' holiday and when she sees a fat man sitting in a deckchair on the deck of a houseboat, he is transformed into a retired pirate.

Jonathan Cape, Ransome's London publisher, and Lippencott in America were sufficiently happy with the sales of *Swallows and Amazons* to press Ransome for a successor. He would have loved to take his Swallows and Amazons on a *Treasure Island* adventure, racing to a Caribbean island with villainous pirates in hot pursuit, but he had signalled to his readers that the Swallows would be back in the Lake District.

The book opens with the Swallows' voyage to Wild Cat Island the following year, but all is not as it had been. The Amazons are hampered by the presence at Beckfoot of their Great Aunt, and the usually competent John wrecks *Swallow*, leaving her crew land bound until her repair. There is plenty of action with discovery of a secret valley, the Amazons' surprise attack and the ascent of Kanchenjunga. Titty practises witchcraft and Roger spends the night with a medicine man after spraining his ankle. The book closes with *Swallow* and *Amazon* racing to Beckfoot, followed by a happy return to Wild Cat Island.

Freed from the Saturday treadmill, work went on steadily with *Swallowdale*, although Ransome was still falling ill from time to time as his ulcer worsened. Nevertheless, when spring came he and Evgenia felt that they could safely take a gentle boating holiday on the Broads. In spite of the little *Swallow* dinghy kept at Bowness-on-Windermere, they both missed *Racundra*, which had to be sold in order to buy their Lake District home, and Broads sailing was the nearest thing.

Welcome at Potter Heigham
1931 Cruise

It is a long drive from Windermere to the Broads and the Ransomes decided to travel by train and stop overnight at Kings Lynn, so as to arrive early in the day. Work on *Swallowdale*, the second of his matchless series, had been progressing well, and only a few days earlier he had taken the artist Clifford Webb sailing on Windermere and Coniston in order that he might make some suitable illustrations. Confident that the book was progressing, Ransome was able to set out on his sailing holiday with a clear mind on Saturday 25 April.

When they arrived at Potter Heigham station they were met by a fat boy with a handcart who was to take their cases to the boatyard. They lunched at the Bridge Hotel and wished that they had decided to stay there the night before, rather than at Kings Lynn or, as they learned at the boatyard, they could actually have slept aboard. Evgenia stocked up for a couple of days at the Bridge Stores and they went on board to sort themselves out. There was to be no sailing for them that day because his great friend Ted Scott and his son Dick were not able to arrive before 6 o'clock. Scott and Ransome had been friends since their Rugby days, and after years of understudying his father, Scott had at last become editor of the *Manchester Guardian*. It had taken a lot of persuasion on Ransome's part before his friend finally agreed that the paper could manage without him for a week. Nevertheless, as soon as he arrived, he arranged for a copy of the paper to reach him every day, and with the help of the younger Walter Woods at the boatyard, he made a list of suitable moorings where he could telephone the office.

When making their bookings it had been arranged that they would hire identical craft. *Welcome* and *Winsome* were small two-berth cruisers. The choice of craft seems a surprising one for two broad six-footers, for Trotsky's young personal assistant, who had invited Ransome to share burnt potatoes in his office, was quite unlike Barbara, Dora and Ivy, the petite fancies of his Bohemian days. Ransome said that *Welcome*'s cabin was even smaller than that of *Kittiwake*, the tiny craft they had sailed the year before *Racundra* was built, so perhaps they were seeking to recapture the spirit of those carefree cruises. The catalogue announced that the berths had sprung mattresses, but having tried them, Evgenia decided that they were not quite the improvement that she had been led to expect.

After a rather sleepless night, they were all off about midday for what turned out to be a delightful afternoon's sail. Scott had little experience of sailing, but had been

The River Ant at Ludham Bridge
The exposed mooring just north of the bridge where the Ransomes endured a violent night.

Fishing at Irstead
A patient fisherman on the staithe at Irstead where the Ransomes waited for the *Winsome*.

meticulous with his 'homework' and after *Welcome* had gained a little to begin with, he was able to keep up with his mentor down the Thurne and up the Bure until they moored opposite the ruins of St Benet's Abbey, close to the entrance to South Walsham dyke.

Here Ransome began to make his list of birds seen in Norfolk (as Dick would in *Coot Club*), with grebes and a heron. After a rather late lunch they carried on, and *Welcome* reached Wroxham around 6 o'clock, just as it began to pour with rain, and they both got pretty wet while they were mooring just below the bridge. Ransome went in search of fresh water from the pub and by making a fuss of their Blue Persian kitten managed to avoid payment. *Winsome* arrived a little later, having sailed across Wroxham Broad, and the two craft rafted up for the night.

After a better night they stocked up in Roy's. 'I have seldom enjoyed anything more than seeing Ted and Dick in the big store at Wroxham, provisioning their boat and buying tinned foods of all kinds with the eagerness of children let loose with unlimited money in a toyshop.'

Once they were sailing again, the Ransomes decided to venture into Wroxham Broad and *Welcome* stuck in the north entrance. Before Evgenia had time to make ready with the quant they were free again, and with a good north-westerly wind they crossed the broad and returned to the river by the south entrance. This was the only occasion when *Welcome* fouled the bottom, and writing of the yacht afterwards Ransome claimed that she could make her way up a ditch!

At Ant Mouth they waited for *Winsome* and had lunch. With the wind coming in strong gusts both boats had a hard time of it reaching Ludham, and *Winsome* got into trouble mooring just below the bridge. Any feeling of superiority that Ransome might have felt quickly evaporated as he tried to go through the bridge. *Welcome* met a hard squall coming dead ahead three times and on each occasion the strong current brought them to a standstill. 'Very humiliating to everybody concerned', he commented, when eventually they managed to get through.

They moored just above the bridge and set up the mast but perhaps unwisely decided to stay where they were for the night. Their mooring had little shelter from the north and both boats endured a violent night being buffeted by a series of rain squalls.

The wind was still from the north but nevertheless they decided to try for Stalham the next morning, and as it turned out they had a fine sail. Evgenia successfully quanted through Irstead Shoals, after which they stopped to have lunch and to wait for *Winsome*. Scott's limited sailing experience had been exclusively on Windermere and the challenge of tacking up the narrow River Ant almost defeated them. Ransome noted that their method was to run aground on the bank, whereupon Scott would shove the boat round with an oar, they would cross the river and promptly go aground on the other bank and so on.

Ransome always maintained that the northern Broads were the perfect place to learn to sail because if newcomers found themselves in difficulty they could always run the bows into the reeds while they consulted a book, find out what they had been doing wrong and have another go. He watched raw youngsters setting sail from Wroxham after a little tuition from the boatmen, tacking with a following wind and getting

themselves into all sorts of trouble, and he looked forward to meeting them a week later when they returned 'their' boat with all the confidence and the skill that they had gained from watching others.

Eventually the Scotts managed to reach Barton Broad and both boats were tacking up the broad when Ransome had his first encounter with some 'hullabaloos' when a motor cruiser charged across *Welcome*'s bows. In his book *England* that was written the same year, Ronald Carton deplored the overpopulation of the Broads by trippers whose 'knowledge of navigation is less than their enthusiasm for high speed in petrol-driven craft'. The antics of a boatload of noisy, inconsiderate visitors would be central to the plot when Ransome came to write *Coot Club*.

After this they had a grand beat across the broad, although *Winsome* managed to strike one of the posts marking the channel, whereupon an angry swan hissed at them, much to Ransome's amusement.

They reached Stalham just as the wind failed and the rain began.

They spent a much more peaceful night and the next morning had an uneventful sail back down the Ant and the Bure to Acle Bridge. Here Evgenia managed to forget to belay the topping lift, the peak slipped and the boom crashed down on the back of Ransome's skull. They feared the worst but fortunately it did no greater damage than to give him recurring headaches for a few days. Ransome wrote in Evgenia's diary, 'Attempted to murder Arthur by dropping the boom on his head. Failed but only just. Better luck next time.'

Nothing daunted, they set off for Potter Heigham, beating all the way against a strong wind. After going through the bridges without mishap, the wind in Kendal Dyke was too much for them but they found a peaceful mooring by Ferry Gate Lane, Martham at the mouth of the dyke. The Scotts left Acle a little later in the afternoon and only managed to reach Potter Heigham, where they collected the mail and stopped for the night.

The wind had changed overnight and they were off by 9 o'clock. Kendal Dyke was reached half an hour later and they had moored in the dyke leading to the Pleasure Boat Inn at Hickling by 10.30 a.m. Here they found a message from Ted Scott who had driven by car from Potter Heigham the evening before, asking them to wait. Ransome was an enthusiastic billiards player but on this occasion he counted the time spent playing with the Scotts in the inn as time wasted.

He admired a fine stuffed pike in the inn parlour weighing 22 pounds. A rather larger specimen would become the glory of another inn in *The Big Six*. The landlord of the Pleasure Boat told Ransome of some people who were tacking across the broad with a following wind and had explained to him that they did so because that was how they had crossed the broad the previous year.

Billiards over, they sailed for the Bure with a helpful north-westerly wind, aiming for Wroxham, but the wind failed as they reached St Benet's Abbey and they tied up for the night by the Horning Hall noticeboard at 8.30 p.m. This was their first visit to what was to become their favourite mooring.

Next day both boats sailed for Wroxham, after calling at the farm for milk and water, but Ransome left *Winsome* behind at Horning, where there was 'consternation

and monkeyhouse'. The south-westerly wind fell away at midday and the long haul back to a mooring near St Benet's was a mixture of quanting, towing and drifting with the wind. Finally they arrived back after dark to hear that Dick had tumbled overboard. 'Daddy's been overboard too,' Dick responded gleefully. 'I went in only up to my middle but Daddy went in up to his ears!'

Ransome's formula for relaxation had worked perfectly. Playing golf, Ted Scott had been able to plan his leading articles, but sailing absorbed him completely. That evening, a copy of the *Manchester Guardian* went floating past *Welcome* still in its wrapper, having been used for cleaning out a saucepan!

Both crews were up early with the intention of having breakfast at Potter Heigham, but it was some time before there was enough wind to let them get away and it took them a couple of hours to reach the bridge. The Scotts had quanted most of the way and arrived exhausted and, their week's holiday at an end, they handed over *Winsome* and returned to Manchester.

After seeing them off, the Ransomes arranged to keep the *Welcome* until the following Monday. Evgenia stocked up for another couple of days and they headed for Wroxham. They had a grand sail down the Thurne and nosed into Womack Broad for a late lunch.

The wind failed them at Horning Ferry and after taking tea at the Swan they trickled upstream through Salhouse Broad before making for the entrance to Wroxham Broad where Ransome caught sight of a kingfisher – his best bird of the trip.

Hunter's Yard
When the Ransomes visited Womack in 1931 Percy Hunter was digging the dyke leading to what is still known as Hunter's Yard — a time capsule of the 1930s. The present fleet of fourteen yachts was almost entirely built at that time. The yachts have no engines and are still lit by oil lamps.

Heigham Sound
Arthur Ransome valued the peace and tranquility of wild places.

They woke to find a hard and gusty north-easterly wind, against which they would have to beat in order to reach Potter Heigham. After a quarter of an hour they decided to take in a reef and by the time they reached Horning Hall they were glad they had. Ransome reckoned that the little boat had taken all that she could stand. Things were pretty lively too, going up the Thurne against the wind in a succession of rain showers, and they arrived at the boatyard, wet through and with a soaking wet cabin. Once it was over they agreed that it was the best sail of the week. They celebrated by having dinner at the Bridge Inn and went to bed in a steaming, wet cabin.

Packing wet clothes is a slow business and although they were up very early, there was a mad scramble to catch the 9.22 a.m. train from Potter Heigham. They had sailed almost 120 miles in the eight days and already they were talking of repeating the cruise next year. 'We are back with copper noses that would do credit to South Sea Buccaneers', Ransome wrote to his mother.

He rejoiced that he had introduced his friend to the pleasures of Broads sailing but it would have tragic consequences. From time to time Scott sailed with Ransome on Windermere and began to read books on coastal sailing, for the Ransomes planned one day to have a sea-going boat again.

The following spring, on Ransome's recommendation, Scott bought a small dinghy to sail on Windermere. It had buoyancy tanks and was effectively unsinkable, so when the little boat capsized in a squall, Dick remained with the boat while his father plunged into the icy water to swim to shore and suffered a heart attack. Ransome was in Syria at the time visiting old friends from Coniston, partly because Dr Ernest Altounyan

was convinced that he could cure Ransome's ulcer. Ransome had written from Aleppo, 'I think she ought to be called *Amazon* because she is exactly like the little varnished boat that used to be *Swallow*'s consort and rival. And by gum I look forward to getting home and going sailing with you.'

On the journey home, with the ulcer troubling him as much as ever, they learnt of Scott's death. For years afterwards Ransome blamed himself, and remembered Scott seeing them off at Salford Docks, full of plans for the Broads holiday that they would take as soon as the Ransomes returned.

Utterly devastated by his best friend's death, there was no question of Ransome sailing on the Broads that year. Instead, once they were back in Britain, he worked at polishing *Peter Duck* ready for the Christmas market and it was not until the spring of 1933 that they returned to Norfolk.

In *Swallowdale* Ransome had briefly introduced the imaginary character of Peter Duck, the hero of the story that the Swallows and Amazons and Captain Flint had made up during the winter holidays in the cabin of a wherry. In the story he had voyaged with them to the Caribbean and returned to Lowestoft 'with his pockets full of pirate gold'. Readers of *Racundra's First Cruise* were quick to recognise Peter Duck as Carl Sehmel, the little old sailor who had crewed for Ransome in the Baltic.

At first, Ransome had tried an ambitious narrative that came to an end after two chapters. The story of the treasure-hunting voyage was to be woven into an account of

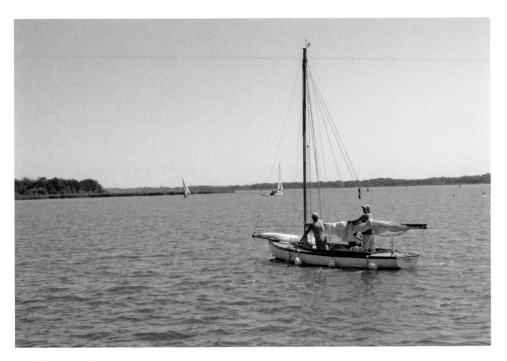

Hickling Broad
Making sail at the mouth of the dyke leading to the Pleasure Boat Inn. Hickling is the largest of the Broads but quite shallow so that vessels have to keep within the marked channel.

day-to-day happenings on board the wherry *Polly Ann*. In her book *Arthur Ransome and Captain Flint's Trunk*, Christina Hardyment published the aborted narrative that Ransome had called 'Their Own Story'. In this version a 'flesh-and-blood' Peter Duck is the wherry's attendant who readily enters into the storytelling. The mixture of realism and fantasy becomes tedious but what remains in the memory is the picture of the Broads in a hard winter. The story opens on a cold, foggy evening with a faint will-o'-the-wisp light moving across the marshes as Captain Flint makes his way back to the Swallows and Amazons aboard the wherry yacht *Polly Anne*. Next morning the fog is as dense as ever, the ropes are stiff with hoar frost and they have a hard job to set the wherry's sail. As the fog lifts and the sun appears, the *Polly Anne* moves slowly up the frosty river accompanied by the sound of the tinkling cat-ice among the reeds. They notice the heads of people above the reeds moving swiftly to and fro, and from the cabin roof see that they are skating on the frozen marsh. Peter Duck warns them that the river could suddenly freeze up at any time.

It was while they were in Aleppo that Ransome began *Peter Duck*, which he called his 'wild yarn', and he made a habit of disappearing every morning to work and then reading bits aloud to the children after lunch. Already there were signs of Evgenia's fierce criticism of his work. Taqui Altounyan remembered 'Uncle Arthur' telling them, 'Aunt Genia thinks it is awful!' The children loved it and so did the critics and so did his public, for copies flew off the bookshelves and the book was reprinted before Christmas.

His next book was quite different. It seems that it was suggested by some American fans who sent pictures of their fun and games in the snow. Drawing on his memories of the great freeze of 1895 when he had been at school in Windermere, Ransome created his own winter wonderland.

It is just after Christmas and the scientific Dick with his romantic sister Dorothea had come to Dixon's Farm for part of the holidays. They signal to Mars (in reality Holly Howe, where the Swallows are staying) and are invited to join in Nancy's latest ploy, an expedition to the North Pole. When a period of quarantine extends their holiday, they base their expedition in the houseboat (now Nansen's *Fram*) before finally making arrangements for a grand march into the frozen north – only there had been just a little too much planning…

If the plot of *Winter Holiday* came fairly readily to Ransome, its execution did not and whenever this happened his stomach trouble flared up. To make matters worse he broke his ankle and was confined to bed. He confided his worries to Wren Howard of Jonathan Cape. 'Things go pretty badly. Ulcer at full blast and I'm hobbled in bed for another fortnight. Book bogged good and proper.' It was not all doom and gloom, for he added that it would be a good book someday. By the end of April, although his ankle still swelled up like a balloon during the daytime, they were both in desperate need of a holiday, and so they decided to return to Norfolk for three weeks' sailing.

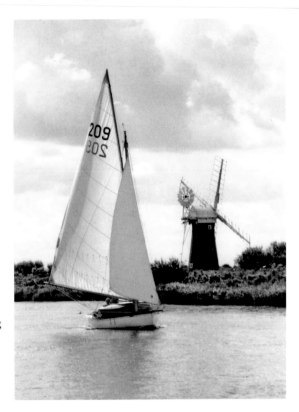

Right: St Benet's Level Windpump
Evergreen ships effortlessly past St Benet's
Level Windpump on her way up the
Thurne. She is one of the modern yachts
built on traditional lines but having a GRP
hull designed by Andrew Wolstenholme.
Evergreen is maintained by Colin Buttifant
at Ludham. (Courtesy Robin Macklin)

Below: River Thurne
The upper reaches of the Thurne are among
the most peaceful on the Broads. The
cruiser is one of a small fleet of traditional
yachts for hire from Eastwood Whelpton
of Upton, near Acle. Their quant is slung
vertically rather than stored on deck.

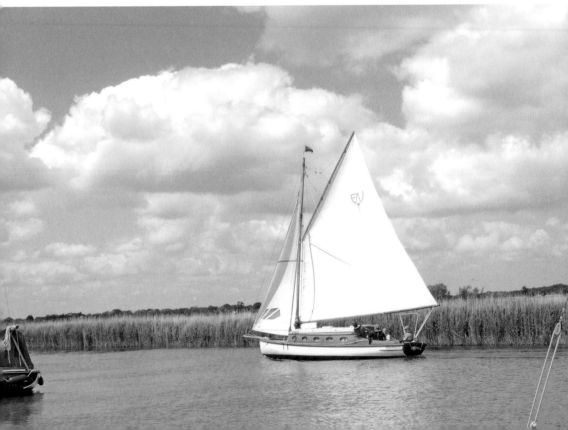

3

Fairway from Wroxham
1933 Cruise

By 1933 the Ransomes had been in their isolated cottage eight years and in that time they had become staunch allies with Colonel Kelsall and his wife, who lived a mile away with their two sons, Desmond and Richard. The boys had posed for 'hollywoods' – photographs from which Ransome drew some of the illustrations for *Peter Duck* – and the colonel had devised signals so that they could be read across the valley that separated their homes. One February evening when the Kelsalls went to tea, the Ransomes tried to tempt their captive audience into joining them on their Broads holiday at Easter time. Although they failed to entice Mrs Kelsall, the colonel signalled a few days later to say that they had hired a yacht for a week.

On Friday 28 April the Ransomes left home at 9.30 a.m. and drove to Jack Powles' boatyard at Wroxham, arriving eleven and a half hours later, tired out, but hoping to be away as soon as possible the following morning. Unfortunately, as their yacht was on hire, they had to spend the night aboard a vacant craft.

The following day the yacht was late arriving back for the handover. By the 1930s, Powles' boatyard was among the largest on the Broads and his yards and boathouses dominated the river south of Wroxham Bridge. The weekly turnaround at the boatyards took time while the army of cleaners made everything ready for the new clients. Finally, after being held up for want of a dishcloth, the *Fairway* left the yard at 3.30 p.m. Meanwhile, they had learned that the previous hirers thought the yacht was very comfortable but not easy to sail, the headsail being too large.

Their *Fairway* class yacht was almost new, the class having been added to Jack Powles' hire fleet that year and described in the catalogue as distinctive yachts with the finest equipment. The cost of the Ransomes' three-week hiring was just £15, including the use of a sailing dinghy. In high summer Powles charged £7 4s a week.

Almost as soon as they left Wroxham they found that their informants were right, as the jib appeared to be too large for the mainsail unless they were well underway. They had a frustrating time trying to beat against an almost non-existent breeze through the trees and bungalows, and the 10-foot sailing dinghy that they were towing made things more difficult. They had planned to spend the night at Horning Hall, but as dusk turned to darkness they moored by Horning Ferry, just as a sudden downpour caught them out and they were soaked to the skin. With both Primus stoves going they tried to do as much drying-out as they could before settling down for the night.

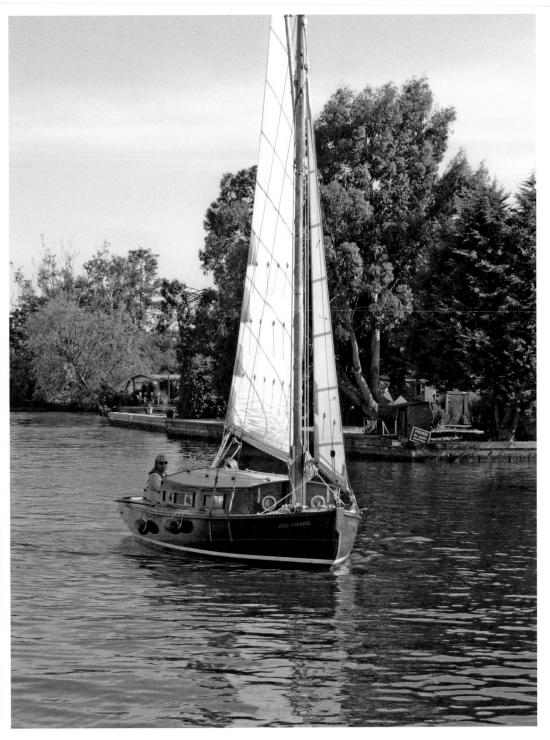

At Horning Staithe
The crew of *Wood Anemone* look at the crowded staithe and try to decide where to moor.
Eventually they moored bow foremost in front of the Swan.

Ransome remarked that the cabin of their Broads yacht felt horribly cramped while they were settling in, but by the third day aboard they had managed to adapt and were not bothered any more.

Colonel Kelsall and the boys were aboard the *Welcome* that the Ransomes had hired two years previously and it had been arranged that the *Welcome* would sail downriver from Potter Heigham to meet them the following morning.

The day did not begin well. Evgenia took a dislike to the water that Ransome had brought from the Ferry Inn, and then, once they were underway and had met the Kelsalls, they had not understood their signal meaning 'voluntary stop'. 'Very sick that our yeoman of signals not up to his job', Ransome grumbled in the log.

They decided that they would all would make for Stalham. There was a comfortable wind for Ludham Bridge and the *Fairway* went through first and tied up, while Ransome watched *Welcome*'s performance. The Kelsall boys, Desmond and Richard,

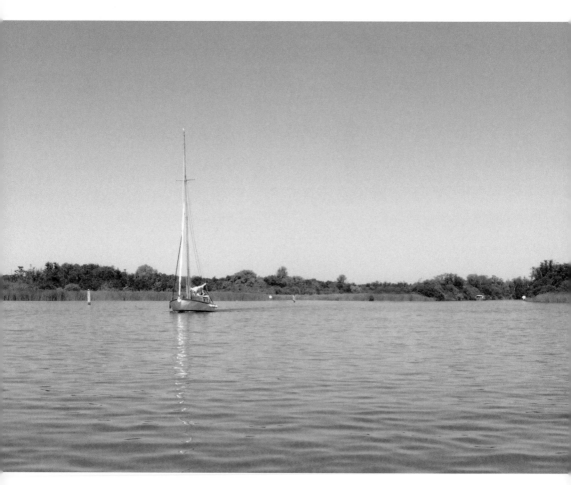

Barton Broad
Looking south across the broad from the Victorian steam launch *Falcon* operated by the Museum of the Broads.

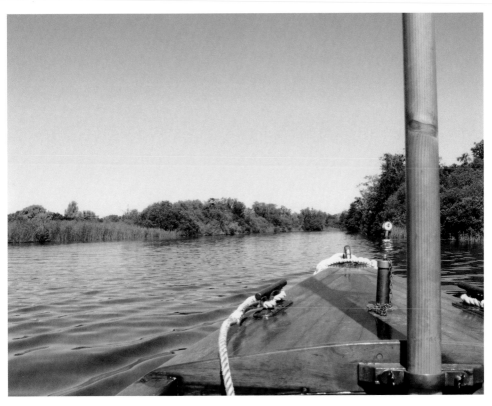

Stalham Dyke
The *Falcon* passing the spot in Stalham Dyke where Ransome listened to snipe and a cuckoo in the dusk.

though inexperienced at lowering and raising the mast, did splendidly and having successfully negotiated the bridge, they were the first away. *Welcome* led up the Ant until it was time to quant, when Evgenia proved more powerful. Finally they had a lovely sail through the difficult bits from Irstead and across Barton Broad towards Stalham, eventually mooring in the dyke about a mile from Stalham Staithe. It was a lonely spot and they watched the mist rising over the marshes as the moon came up and listened to some snipe and a cuckoo calling in the dusk. It was a delightful end to the day, except that they were rather worried by the non-appearance of the *Welcome*.

They left Stalham next morning bound for Barton Staithe and on down the west side of Barton Broad towards Callow Green. They met the *Welcome* where the Kelsalls had stopped for the night, having wasted the good wind while they tied up to make tea. *Welcome* now needed to sail for Stalham for food and so they agreed to meet up later in the day at Irstead. They explored around Daston Staithe and on the return to the main channel by Callow Green, Ransome failed to bring the *Fairway* around quickly enough (that jib again?) and she ran onto the soft mud out of the channel. Evgenia towed in the dinghy while Ransome did what he could with the quant, but the mud proved too soft. Ransome went from bow to stern and back again, shifting his 16 stone,

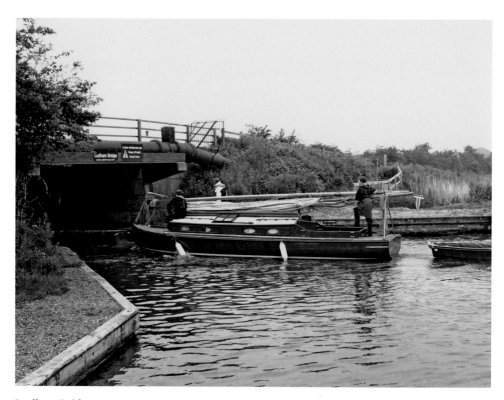

Ludham Bridge
Well equipped for a wet morning, a sixth-former on a school cruise steers with a foot on the
tiller as *Lullaby* from Hunter's Yard is towed through. *Lullaby* starred as the *Teasel* in the BBC
adaptation of *Coot Club*.

and they eventually managed to reach deeper water. Thoroughly at home at the oars,
Evgenia towed through the narrows until they could lay a course for Irstead. Here they
had lunch while waiting for the Kelsalls and they watched the peak of a large black sail
over the reeds come gradually closer, until at last a fine 'business wherry' came sailing
through.

Once *Welcome* had joined them at Irstead, Ransome took Desmond and Richard in
turn sailing on Barton Broad in the dinghy. Then, having decided to carry on once more,
they allowed *Welcome* to get well ahead before they sailed. Unfortunately they had not
waited long enough and soon caught up, only to find that *Welcome* was tacking to
and fro across the narrow river making very little progress. Ransome decided to wait,
but he could not bring *Fairway* head to wind as the jib took control and they gently
rammed the bank. When eventually they caught *Welcome* a second time, they tied up
and had tea. Finally Evgenia towed through the narrows and they sailed to Ludham
Bridge without the jib.

Once safely through, they experimented and found that beating without the jib they
had none of the previous difficulties. Finally, both crews brought up at Horning Hall
Farm and had the awnings up and all snug by 7.30 p.m. They all watched fascinated

while a boy from the farm set his night-lines and eel traps, and the next time that they used the mooring Ransome had his own night-lines to put out.

The following day was very cold with a biting wind, so there was no sailing. Instead, both crews walked to the nearest bus stop on the Horning to Ludham road and Colonal Kelsall went shopping in Potter Heigham and Ransome went to Yarmouth and returned with oilskins and boots for himself and for Evgenia. It was bitterly cold aboard both boats and their crews decided on a very early night in the hope of better things in the morning.

There was a steady north-easterly wind and it was much warmer the next day, so that they were able to have an enjoyable sail to Wroxham. The Kelsalls were off first, but were caught and passed when the *Fairway* picked up a good wind as they were crossing Wroxham Broad, while *Welcome* kept to the river. After one look at the crowded reach by the boatsheds, Colonel Kelsall turned back without waiting to stop for lunch and found a mooring beyond the last of the bungalows, near the entrance of Wroxham Broad. He was already a little fearful that without an engine he would not be back at Potter Heigham in time to hand *Welcome* back.

Wroxham
This 1960s view from near Jack Powles Boatyard shows the wherry *Albion*, J. Loynes & Sons boatyard across the river and the old granary by the bridge, none of which exist today.

Ransome collected the telegram from Herbert Hanson, the secretary of the Cruising Association and an old friend from *Racundra* days, who was going to join them for their voyage through Yarmouth. He took their dinghy through the bridge and sailed up the reach by the church, finding to his great pleasure that under sail he could come with a few feet of nesting waterhens, and he spotted some little brown birds that he thought were reed warblers. Evgenia was less fortunate, and cross with herself for forgetting that it was early closing day in Hoveton!

Evgenia's moods never lasted long and the following morning, after she had done their shopping, they sailed the *Fairway* into Wroxham Broad, and she took the helm so that Ransome could watch a family of grebes having diving lessons and giving lifts to the youngsters on their backs. The three young birds tried to dive but Ransome could see that they could never get much below the surface.

A mixture of drifting with the tide, beating and then quanting eventually brought them to Thurne Mouth. There was a fair wind up the Thurne except for the last part through the bungalows up to the staithe, where they found Hanson waiting for them on the bank. Apparently the Kelsalls had already handed over *Welcome* and left for home. They decided to wait and see what the weather was like the following morning rather than making firm plans for the voyage south that evening.

They were up at 5 o'clock and off at 8.45 a.m. beating down the Thurne, and had passed under Acle Bridge by noon. Thanks to Hanson's experience they successfully arrived at Yarmouth with the last of the ebb, although the wind fell away as they reached the first of the bridges. Having lowered the mast, Hanson towed along the towpath through three bridges, and then in the dinghy towed under Breydon Bridge that happened to be closed at the time and they were out on Breydon Water by 3.45 p.m.

There was a light wind and the tide was with them but when the wind fell away again, Hanson, who was in a hurry to catch a train, started to tow once more and he had to work hard to keep ahead of the *Fairway* whenever a puff sent the yacht on her way. They turned up the Yare, but Reedham Bridge was closed so they lowered the mast and the noble Hanson towed them through again and helped them moor. It was too late for him to catch his train, so they retired to the Nelson Inn for a meal, and in spite of their early start were late to bed. They had sailed and towed 26 miles from Potter Heigham.

Another early start, with breakfast at the inn at 7 o'clock, enabled Hanson to be off to catch his train at Reedham Station. The *Fairway* sailed for Norwich two hours later with a fair wind, except in the Surlingham reach. Near Buckingham Ferry they saw a Thames barge that was being towed downriver by a small trading steamer. They turned back within sight of Carrow Bridge and moored by Girling's boatyard at Thorpe, and in the afternoon they caught a bus into Norwich, but Ransome's ankle was very painful. It was Saturday and the place was 'swarming with people' and it was unbearably hot. Returning to the *Fairway* they found that they had missed their tide, so they decided to spend the night where they were, although Evgenia let it be known that she had a poor opinion of the mooring that Ransome had chosen.

It was much colder and pouring with rain next morning so they decided to stay put until the rain had stopped. Evgenia thought Thorpe was a very inhospitable place, being too full of motorboats. She was pleased to see Arthur resting his foot that was very swollen, but wished that they were spending the day at a more attractive spot. There was no let-up with the rain and they remained on the mooring all day.

Ever methodical, Ransome noted the times of high and low water along the rivers before they set off for Oulton the next day. It was after midday before they left Girling's and they stopped after only a couple of miles at Bramerton Woods End Inn. Here the willow-fringed bank makes it one of the most beautiful spots on the Broads. Ransome's log makes no mention of this, only that they both had a very good glass of Gaymer's draught cider and watched the landlord having a game of skittles played with a 'wooden cheese'. When they were invited to join in, Evgenia hurled the heavy 'cheeses' with great force!

After this distraction, they sailed down a lovely part of the River Yare with a good wind and tide to help them, and on through the New Cut. At Haddiscoe Bridge they were held up while a yacht beat up the cut from the other side, in order that they could pass through together. Once in the Waveney they had the tide against them and after Somerleyton the wind began to drop. Evgenia towed until, tired right out, they poled the last few yards into Oulton Broad and tied up to the first available buoy, just as it was getting dark.

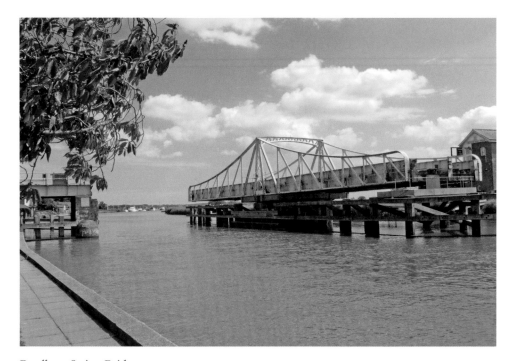

Reedham Swing-Bridge
The bridge still crosses the River Yare at Reedham, but with fewer trains it is open for longer periods than in Ransome's day.

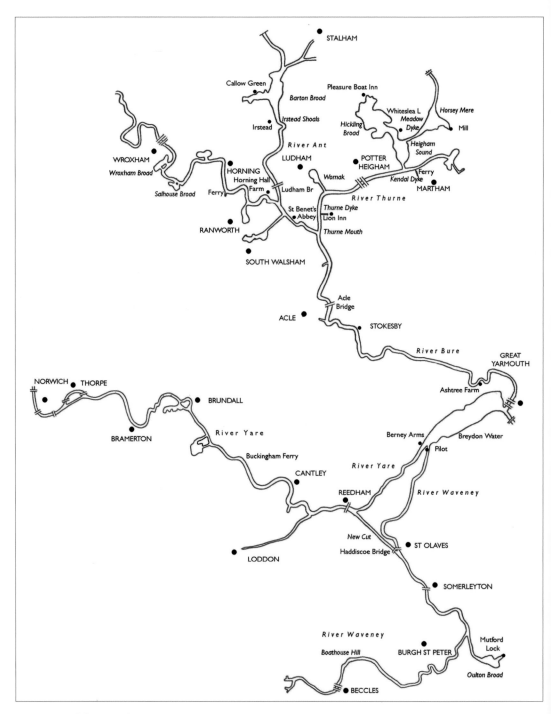

Map of the Broads

They spent a very uncomfortable night and awoke to a morning of rain and half a gale. They took a reef in but did not like to move until the wind moderated. Instead, Ransome went exploring in the dinghy and came back astern of the kindly harbourmaster's little motorboat. In the afternoon, although the wind had increased to near gale force in the broad, they fairly flew across and tied up to the quay without a bump. The shops in Lowestoft proved a great disappointment so they returned to watch the craft passing through Mutford Lock to and from Lake Lothing and chatted to the harbourmaster (who would appear in *Coot Club*) about boats that were for sale. In the evening they had hot baths before bed – another incident that would have its place in *Coot Club*.

'It feels funny to be so well washed,' commented Evgenia in her diary.

With rain beating down all day and a cold wind, they spent the next day in the yacht harbour 'fraternising with the natives', as Evgenia put it.

The following morning they were up at 7 o'clock and off an hour later, bound for Beccles, having decided to take a chance and not reef. There were several occasions before they were safely tied up at Beccles when they wished they had done so. Having passed very few possible mooring places on the way, they finally moored beside the Thames barge *Pudge of Rochester*, which was tied up to the quay at Beccles Saw Mill, carefully avoiding the corporation moorings opposite because they were on the

River Waveney near Beccles
This pleasant mooring, quite close to the town, has become overgrown through lack of use.

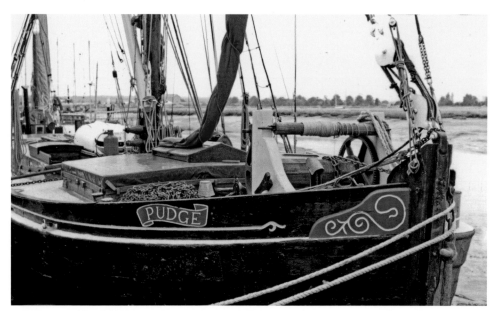

Pudge

In June 1940 *Pudge* was one of about thirty spritsail barges that went to the beaches of Dunkirk as part of 'Operation Dynamo' to rescue the British Expeditionary Force. These days *Pudge* is operated by the Thames Sailing Barge Trust and based at Maldon.

lee shore. *Pudge*'s crew told them that they had been as far as Truro, Gravelines and Hull. The mill owners did not take kindly to visiting yachts making free use of their moorings and told them to leave. When the wind dropped they crossed the river to a vacant mooring at the yacht station. Here they had an encounter with a pair of young 'Beccles sharks', as Evgenia recorded in her diary:

> Presently two pretty small girls with large and innocent eyes came to ask if we wanted any milk so I told them to bring me some. After paying them two sixpences we could not get rid of them for a long time. Arthur gave them some pennies to go to the pictures and then when he was gone and my back was turned the bigger girl said she dropped one of the sixpences in the river. So I gave them another and told them to clear out. Later on two girls turned up again with the same offer of doing some shopping for us, either sisters or the same girls in different clothes. I am sure they are very clever in extracting money from unsuspecting yachtsmen, and dropping money in the river is certainly a fine trick.

The harbourmaster told them that the girls belonged to a notorious family of thieves and having been trained by their mother were up to all sorts of tricks.

That evening Ransome was intrigued to watch a fisherman babbing for eels from his houseboat.

As it was raining in the morning they went aboard the houseboat that had at one time been the Caister lifeboat. They found an unusual couple living there, the husband, who

only thought about eels and told Ransome that eel babbing was 'the most beautiful sport in the world', and his literary wife whom they thought had an odd taste in books – Fiona Macleod, Alice Meynell and J. A. Symonds.

As there was so little wind, Evgenia quanted downriver to 'Boaters' Hill (Boathouse Hill) mooring where they talked to the 'harbourmistress', who was gardening, and had a brief and unsuccessful hunt for snakes. Readers of *Coot Club* will remember that Mrs Barrable's brother Richard had caught a grass snake there and was punished for taking it to school.

Once the tide was beginning to help they set off again. Evgenia quanted through the swing-bridge at Aldeby but there was very little wind. Burgh St Peter was reached at 5.55 p.m., and with 'a lot of determination' by Evgenia and a helpful tide they tied up just beyond Somerleyton swing-bridge at 8.30 p.m., in company with *Happy Times* and *Happy Days*, large five-berth yachts whose crews kept the Ransomes 'entertained' until late into the night with their 'hideous singing'. Only a few years previously in a guide to the Broads, W. L. Rackham had urged visitors not to play their ukulele at all hours, and pointed out that houseboat roofs were not intended for jazzing or dancing the Charleston. By the 1930s wireless and gramophones had replaced the ukulele as popular on-board entertainment.

Ransome was up at 7 a.m. next morning in an effort to make the most of the tide, and without even a pretence of washing they sailed at 8 a.m. into a gentle headwind, as the tide was already ebbing quite strongly. After Haddiscoe Bridge they were blanketed from what little wind there was by 'odious disused works'. At St Olaves they moored by Johnson's Yacht Station so that Ransome could telephone Yarmouth Yacht Station to arrange for a tow through the bridges. He was unable to get through but Mr Johnson

Surprise Says 'Come Along'
From a photograph.

Breydon Water
The expanse of water at high tide is deceptive for craft must still keep to the marked fairway.

said that he was just off to Yarmouth on his motorbike and would leave a message for them.

There was just a short reach after St Olave's when they had to tack. Ransome 'tried to cheat the wind' and was caught out by an eddy and they rammed the muddy bank. Evgenia had to do heroic work with the quant once more. Shortly afterwards, they were caught and passed by the *Pudge* coming downriver under power and topsail.

Ransome was about to cut the corner by the pilot boat at the mouth of the river, but the pilot called out to tell them to keep well away – another incident that would find its way into *Coot Club*. They had a grand sail across Breydon that was spoilt when they realised that they had misjudged the tide and were still too early to get through Yarmouth. They were very relieved to see 'Old Burbar' and his tug *Surprise* waiting for them well above the Breydon swing-bridge. Burbar took their rope and they were off, lowering the mast while underway. The bridge opened for the *Pudge* and they were able to slip through behind the barge. There was a 'tremendous' tide pouring out of the Bure but the *Surprise* easily towed them up beyond the 3-mile house to Ash Tree Farm where there was the first possible mooring above Yarmouth. It was not much of

a mooring, simply some half-submerged piling, but they were very tired after twelve and a half hours since leaving Somerleyton.

They spent a restless night being buffeted against the piling by a squally north-easterly wind and were off soon after 10 o'clock, very pleased to be back in northern waters once more, having left behind the region of 'concrete piers, submerged decayed piling and strong tides'. As Evgenia remarked, they had almost forgotten what sails looked like while sailing in the southern rivers, where they seemed to meet nothing but motorboats. They reached Acle Bridge around lunchtime and moored just above the bridge. It was a fine Sunday morning and all the world seemed to be on the water. Their meal was violently interrupted by a sudden confusion of boats trying to get through the bridge. Seeing that one was about to ram the *Fairway*, Ransome rushed into the cockpit to lower the fenders and cracked his skull on the doorway.

On the way to Thurne Mouth they met a 'proud boy' sailing an 8-foot pram dinghy – the inspiration for Tom Dudgeon? North of Acle Bridge they ran into a succession of squalls and the *Fairway* kept heeling over to the sound of tumbling crockery in the lockers until they had reached Horning. Horning Reach seemed absolutely crammed with boats. They narrowly avoided a collision on one occasion by putting the yacht about as an overtaking motorboat, whose steersman was too busy paying attention to other motorboats, was about to ram them.

Just opposite the Swan Inn, another large craft loaded with people overtook them and refused to give the *Fairway* the room to go about after Ransome asked for it and so bumped their 'indignant' side twice, calling out by way of justification that it was 'not a parade ground'. In *Portrait of the Broads*, J. Wentworth Day says that there was so much vandalism and irresponsible behaviour by certain clients at this time that the boat-hirers compiled and circulated a blacklist.

Pressing on towards Wroxham, they found that there were more leaves to blanket the wind than when they had sailed downriver a week or so earlier, and they had a struggle to reach Wroxham Broad, while Evgenia kept complaining that she had not wanted to go that way at all. Once in the broad they again they found all the wind that they could handle. It was 7.30 p.m. before they tied up at Jack Powles' yard, much later than they had planned. Having made things tidy aboard, Evgenia dragged Ransome to see the local doctor. Dr Bennett examined his head and announced that Ransome had not broken his skull. It was very late before they got to bed, thoroughly tired out.

Perhaps it was because they were so tired when they went to bed that they had a really good night. Most of the next day was spent at Jack Powles' yard, which was practically empty at the time, dealing with a bundle of letters, varnishing the wounds where the cruiser had struck them and filling up with oil and water. At the yard they fell in with a couple of 'elderly birds' aboard the hire yacht *Comet* and arranged to meet up again beyond Horning. Having thrown their backlog of unopened papers overboard, they sailed shortly after 4 o'clock with a gentle following wind and helped by the tide they enjoyed four hours of 'delightful aquarium sailing' before tying up at their old mooring by Horning Hall Farm.

Ransome went off to the farm for milk where a farmhand gave him some worms so that he could lay out a night-line for eels.

When Ransome took up the line next day he found it a tangled mess, every bait taken and only a single good eel, which they enjoyed eating fried for their lunch. The Death and Glories in *The Big Six* would have the same trouble catching eels. They had a gentle sail up the Ant to Ludham Bridge where they caught up with the *Comet* to discover that the skipper was the vicar of Horsey and a great fisherman. It was still quite early in the day, so they decided to make for Potter Heigham and very soon wished that they had not. The wind fell away and it began to rain, and when they eventually arrived all the decent moorings were taken and they had to make do with a very poor one by some broken pilings. By then, they were soaked and the *Fairway* was wet inside and out. Evgenia confided, 'I [am] very cross with myself for not sticking to our own nice moorings by Horning Hall Farm. [It was the] kind of weather we had to explore, but being cross with me always makes me cross with Arthur especially when I am very cold and wet as I am now and our neighbours very humorous and noisy.' When they had dried out, Ransome smoked two pipes to cheer himself up while Evgenia designed a new *Fairway* with better accommodation!

All crossness forgotten, next morning Ransome towed through the bridges and he thought that Evgenia steered very well. Their trouble began when they found that what had seemed to be a favourable wind when they had set off was in fact a gentle headwind. After reaching through Kendal Dyke, Ransome towed through Meadow Dyke until they could sail across Horsey Mere to tie up in the narrow dyke by the windmill. Here Ransome took the opportunity to walk to the village to post letters and when he returned they manhandled the *Fairway* round and sailed out under jib alone, setting the mainsail underway once they were outside. They tried for Catfield, but took one look at the narrow dyke and decided to return to Potter Heigham. Once they reached Kendal Dyke they had to quant for a few yards 'cursing as usual' – presumably Evgenia. Once through the bridges they decided to go on rather than face another night on a poor mooring. They sailed on down the Thurne in the dusk and tied up near the ruins of St Benet's some time after ten, when it was really too dark to see what they were doing.

Ransome listened to some reed warblers while he set the night-line before settling down for another late night. Earlier in the day he had watched two coots with a family of five chicks in Whiteslea.

Writing in the log, Ransome says that Evgenia had been in a very critical mood that day ('By then my hat, my sailing, my boom, my ears, my quanting, my steering were all wrong so Genia took over completely') but there is no hint of this in the full account in her diary. Her explosions never lasted long. By this time they had been cooped up in the small cabin of the *Fairway* for more than a fortnight.

Sailing into South Walsham Broad with a good easterly wind the next morning, they came upon a cruiser full of people with some sort of lecture going on aboard. Once the *Fairway* was within earshot the lecture stopped abruptly and some of the listeners dived into the water and others pretended to be sunbathing. Evgenia took a photograph that

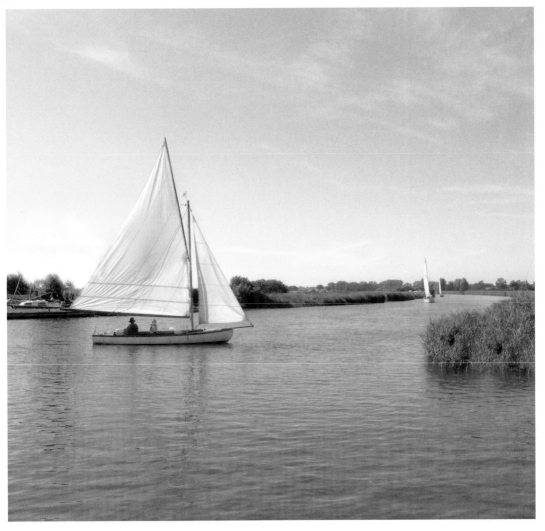

From Thurne Dyke
The windswept reaches of the lower Thurne provide for some grand sailing.

those aboard the cruiser seemed to resent. According to her diary they had come upon a 'Communist Summer School'.

They planned to have a gentle last full day and so returned to their old mooring at Horning Hall Farm where they watched the racers from Horning Sailing Club. Soon afterwards a 'communist fleet' of three boats passed by, one of them had a gramophone playing on the cabin top and a carried a punch-bag on the after-deck. When they recognised the *Fairway* they took out binoculars and stared at the Ransomes. Little did they know they were looking at Trotsky's one-time personal assistant!

The peace of their afternoon was shattered again when an 'Empee' speedboat roared past bringing down pieces of the bank with its wake. Towards evening they

were passed by a whole crowd of the boats from Jack Powles' fleet heading upstream and they feared there would be a scramble for berths at Wroxham the next day.

Off by 8.30 a.m., they had an easy sail to Wroxham, arriving five hours later to find the yard deserted. They had sailed 212 miles over three weeks. Evgenia sent a message to Jack Powles to come to the *Fairway* so that she could show him the improvements that he needed to make. They idled away the afternoon sitting in the sun and slipping over to Roy's for ices, deliberately leaving the cabin just as it was to show just what it was like when people were actually living on board. When the time came to go across to the King's Head for dinner, Jack Powles had still not turned up. They both disliked the meal but were not sure if it was the food or the result of eating too many ices. They returned to the yacht to find that he had been twice while they were away, and had left a message to say that he would try to catch them in the morning. It sounds as if Jack Powles knew Evgenia rather too well!

Up early, they packed and tidied up the yacht with Evgenia cursing Mr Powles who had still not appeared, and regretting that their packing had not been completed at their leisure the previous afternoon.

They caught the local train from Wroxham to Thorpe Station where they separated without properly saying goodbye. Evgenia had to rush to catch her train to return to Windermere via Peterborough, Rugby and Crewe, and Ransome was heading for Aldburgh and then on to London. He arrived home a day or so later, having bought a year-old Austin motor car, and convinced that there was a good book to be written about sailing on the Broads if only he could manage it.

Wood Anemone
Aboard *Wood Anemone* from Hunter's Yard making a crossing of Barton Broad with the Venturers.

4

Prostrate in Kendal Dyke
1933 Fishing Trip

Winter Holiday was published in time for the 1933 Christmas market, having occupied its creator almost every day throughout the whole of June, July and August. Once the proofs had been corrected and he had drawn the endpaper maps, he was free to return to Norfolk in search of some good fishing at the end of September. Ransome tells the story in this autobiographical draft:

Charles and Margaret Renold were friends that we had made through Ted Scott. He was then managing director of a firm that makes bicycle and other chains for all the world. She was that rare being that authors find it hard to believe. She was a reader who never wanted to write a book, and one who, if she liked a book used instantly to go to a bookshop and send copies to all her friends. We were very fond of both of them, and I had turned Charles into a fisherman, and not a mere flyfisher but one who shared my pleasure in the sort of fishing I had had in Russia, float fishing for course fish.

Now there is no better coarse fishing than on the Broads in autumn and we used to go there hiring a motor cruiser (our object being fishing, not sailing) with a sailing dinghy however, in case of backsliding on my part. I reached Manchester feeling ill, but thought it was only my usual trouble and that the salt air of the coast would put me right. Charles drove me from Manchester to Potter Heigham, where we put our gear into a motor cruiser [Charles Renold's heroic rescue of the prostrated Ransome would probably only been possible aboard one of the small 'Starlight' cruisers with a stern cockpit] and set off at once up the river and into Kendal Dyke, stopping on the way to arrange for the necessary supply of milk from a farm just above Potter Heigham, and taking some with us for that night and the next morning.

Fishing started well next day, though I was feeling worse with pain in quite new places, and at the appointed time I hoisted sail in the dinghy and left Charles fishing aboard the cruiser and sailed off to the farm. I tied up there, leaving the sail still standing, bought my two bottles of milk and put them in the boat and was not quite satisfied with the set of the sail. It needed, I thought, an extra swig on the halyard. Drifting in the river I gave it that extra swig. It was as if some villain had stabbed me in the vitals. I collapsed in the bottom of the boat and could not get up. The slightest movement seemed to threaten some sort of permanent tearing at my inside. Luckily the wind was light. Though a headwind for my return. However it was a kindly little dinghy, and lying in the bottom of her, in the position that seemed best to ease that horrible pain, I sailed her up the river. I was fortunate in not

meeting another boat. Lying flat I could not see much, and steered with a finger on the tiller above my head. Whenever I saw reeds over the gunwale I put her about, and in this way I managed to take her back to Kendal Dyke and to the cruiser.

Charles, fishing, saw the little boat and judged from my sailing that there was something wrong. Somehow he managed to help me out of the dinghy and into the cockpit of the cruiser. He then became, every inch of him, the managing director, laughed at the idea of not seeing a doctor, and presently, aided by me, started the engine, cast off from the bank, and set off for Potter Heigham. It was already dusk when we arrived, and he went ashore to get me a bed in the inn and to telephone for a doctor. He came back more angry than I have ever seen him. The people at the inn, no doubt fearing that I had some kind of infectious disease, absolutely refused to take me in.

The only doctor that we knew of was at Wroxham, Dr Bennett, who had been very kind to Genia and me on earlier visits when things had gone wrong. There are 12 miles of winding river between Potter Heigham and Wroxham and sailing after dark is not allowed. Charles, in charge of such a boat for the first time, took her right through to Wroxham, where the landlady of the inn by the bridge had me in bed with a load of hot bottles in about five minutes and sent for Dr Bennett. He came, had one look and telephoned to Norwich for Blaxland, to whom subsequently I was to owe my life twice over. Blaxland came first thing in the morning, had a look and said an operation would be necessary. By that time, after lying still all night and with Mrs Painter's hot bottles, I was feeling better, and being naturally unwilling to upset Charles's week of holiday, said I would come into hospital at the end of the week.

'You won't do that,' said Blaxland, 'because if we put off the operation till tomorrow, you will not be here next week to be operated on. You will be dead.'

'Go ahead', said I.

And Charles with great foresight and energy, had already retrieved his car, ran me into Norwich, where Blaxland was waiting for us, and I was operated on then and there for acute appendicitis. A week later something went wrong and Blaxland did his life-saving just in time. Genia, who happily, did not know of the operation till it was all over, closed down Ludderburn and came to Norwich, and three weeks later I was sitting in an armchair on the lawn of the King's Head at Wroxham, wrapped up in blankets, it being half-way through October, and Genia and I were much enjoying ourselves watching the dipping of our floats.

I remember chiefly the extraordinary kindness of our friends. Margaret came from Manchester to join Charles and fairly swamped me with detective stories. Hanson of the Cruising Association, came down to talk boats. The Kelsalls drove all the way from Windermere. And finally, Howard of Cape's drove down from London, bringing Molly Hamilton with him, and best medicine of all, an early copy of *Winter Holiday* and the news that they wanted me to start the fifth as soon as I could.

That fifth book would be *Coot Club*.

Sail and Power
1934 Cruises

None of the surviving notes for *Coot Club* are dated, so it is not possible to say with any certainty how far the plot had been developed by the time the Ransomes set off for another three weeks' Broads cruise in the spring of 1934. The trip was to be a holiday with a purpose, for Ransome was looking for any local colour or incident that might bolster his scaffolding, and he needed to take photographs along the rivers from which, thanks to his publisher's insistence, he would do his best to make the necessary illustrations.

The story of the cruise is less well-documented than the earlier ones. Evgenia did not bother with her diary and after the first week Ransome's log contains little more than place-names.

Although Evgenia had reservations over the cabin, they hired another *Fairway*. On 14 April they left Wroxham even later in the day than they had the previous year, Ransome was relieved to find that the trees along the upper reaches of the Bure were still bare, as the wind was light and from the east. Three hours later they tied up at Horning just as it was getting dark.

Leaving Horning against another easterly wind, they passed through Potter Heigham around 1 o'clock and moored in the dyke by Horsey windmill by 5.30 p.m. Here they found that their neighbours included a couple of Rugby schoolboys who were duly invited aboard to exchange experiences.

Somehow, while they were there they managed to fall foul of Major Buxton, the owner of Horsey Mere and the Horsey estate, a 'very unpleasant hostile fellow' with a 'decent' wife. They sailed across Horsey to Whiteslea where they met Jim Vincent, the widely admired head keeper on Lord Desborough's estate, who had made Hickling a haven for bird life. He took them to the shooting lodge to see some of John Gould's bird prints. He also showed them a Broads punt that Ransome carefully measured and photographed. Later they heard their first cuckoo of the year and watched a marsh harrier quartering Horsey Mere.

A light easterly in the morning encouraged them to make for Wroxham, but when it died, Evgenia had to quant the last 2 miles through the bungalows.

The key episode in the new book was to be the deliverance of a nesting bird and its eggs from a crowd of noisy hullabaloos. Ransome was uncertain whether to have a coot, a water rail or waterhen. Nobody knew more about Broadland birds than Jim Vincent, but in order to satisfy himself, Ransome went to Norwich in order to meet Dr Sydney Long, the honorary secretary of the Norfolk and Norwich Naturalists Society,

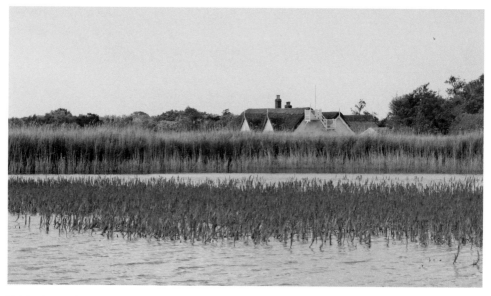

Whiteslea Lodge
Lord Desborough's shooting lodge that Arthur Ransome visited to view John Gould's bird prints.
The single story building has adjacent stairs up to the 'lookout'.

who had himself started the Trust in 1926. The Trust appointed 'watchers' to look after the birds – forerunners of the *Coot Club*'s Bird Protection Society – and readers of *The Big Six* will remember that the cabin of the *Death and Glory* is decorated with pictures given by a friend in the Norfolk and Norwich Naturalists Society.

Dr Long was most interested in the story that Ransome outlined and helpful. He told Ransome that his notion of a nesting water rail was not really a very good one, as the bird was too difficult to see. A coot or waterhen would be better, but as the waterhen nests in bushes or rushes and coots build their nest on the water he suggested a coot's nest. That was good enough for Ransome, who determined upon a coot's nest on the spot.

Leaving Wroxham shortly after midday they found the light south-westerly wind had strengthened and once more met several hard squalls crossing Wroxham Broad. They had a late lunch while taking in a reef at Salhouse, and after tea at the Swan, shook them out again before sailing to Ludham for water, before returning to the mouth of the Ant for the night.

Returning to Horning, they picked up a telegram from Wren Howard to say that he would be unable to join them for their voyage to the southern waters. This was a disappointment, for G. Wren Howard, Jonathan Cape's partner, had looked after Ransome's books from the start and the two had become good friends, apart from which, an extra pair of hands would have been very welcome on their passage through Yarmouth. Without the patience, wise counselling and encouragement of Wren Howard, it is more than likely that the production of the Swallows and Amazons books would have faltered long before it did.

Ransome added a note in his log that the leaves on the willows were coming out so rapidly you could almost see them appearing!

They spent two days at Horning and on Saturday they left for Stokesby. The next day they passed through Yarmouth to Somerleyton. Here they saw a bittern, a heron being mobbed by gulls and other birds wading on the sandbanks.

On the way to Oulton next day they ran into a hailstorm and once it had passed, Evgenia took the broom and swept the decks clear.

Tuesday	Oulton–Beccles–Reedham
Wednesday	Reedham–Brundall
Thursday	Brundall. Evgenia visited the dentist in Norwich.
Friday	Brundall–Yarmouth–Stokesby
Saturday	Stokesby–Potter Heigham
Sunday	Potter Heigham–Horning Hall Farm
Monday	Horning Hall–South Walsham
Tuesday	South Walsham–Ranworth
Wednesday	Ranworth–Wroxham, arriving in a downpour, their three-week holiday at an end, having sailed 178 miles.

Once the struggle with *Coot Club* was over and the manuscript was safely at the printers, the Ransomes embarked on a further Broads holiday. In spite of their views on motor cruisers, they hired the *Royal Star* or the *Regal Star* (Evgenia called it the *Noble Star*) from Jack Powles for a week's fishing.

They spent the night of Thursday 14 September at the King's Head Hotel at Wroxham.

Stuffed in the back of Evgenia's diary are the receipts for their holiday, at prices that today seem almost beyond comprehension. Their overnight stay at the King's Head cost 9s 6d. Dinner set them back a further 4s with an additional 4d on spirits. At that time the Swallows and Amazons books were selling at 7s 6d.

Next morning Evgenia stocked up at Roy's - bread, sandwich spread, tea, coffee, cornflakes, butter, 24 eggs, pasties (liver and bacon, steak and kidney and chicken and ham), ginger nuts, Horlicks, Jacob's cream crackers, soda water, soap, apples, tomatoes, beans, carrots and peas. Elsewhere she bought cheese, ham, sausage, cake, tartlets, asparagus, bananas, pears, plums, milk, matches and paraffin. Altogether she spent £3 11s 11d.

Evgenia bought milk each day and she visited the Bridge Stores at Potter Heigham a couple of times for small items, and towards the end of the week they needed some more paraffin. Including their 4s fishing licences they spent £5 4s 2d during the week.

For the first two days they fished in the Bure, before the attractions of better sport drew them to the upper Thurne, Kendal Dyke and Horsey. They had their usual daily competitions, taking account of the number caught and the best fish of the day.

From Ransome's daily record of work, it seems that he was still finishing off the illustrations, for on the fifth day of the holiday he posted seventeen full-page illustrations to the publisher.

It would be almost four years before Ransome returned to the Broads and when he did so, it was as 'Barnacle Bill', the leader of the fleet of 'Northern River Pirates'.

6

Coots and Foreigners
Coot Club

After *Peter Duck* was published, Helen Ferris of the American Junior Literary Guild wrote to Ransome saying, 'For your next boys' and girls' book why don't you do something entirely different with a new set of youngsters? That is, not Swallows and Amazons by name so to speak. I think it would be a very good idea both from the business point of view and from the sheer fun you would have tackling new material. How about it?'

Helen Ferris was actually echoing Ransome's own thoughts, but the attraction of writing a winter tale with its echoes of the Great Frost of 1895, when he had been at school in Windermere, proved too great. Now, having made up his mind to set his next book on the Broads, he was free to follow her suggestion.

The first hint of the new book came in a letter to his mother on 1 December 1933, while he was convalescing in St Mawes after the operation for appendicitis. There can be no doubt that although the Lake District would remain his first love, he was strongly attached to the Broads and its wilderness beauty and abundant wildlife:

> I wish I had a good plot for my next book. It is to be placed on the Broads, with all those rivers, and hiding places in the dykes and little stretches of open water. Really a lovely setting, with herons and bitterns, and fish, very wild except just in the holiday months. But, as usual, though I have five youthful characters and one old lady, I haven't the glimmering of a plot. (Keep this secret: about the Broads, I mean.)

He thought his old lady should be living aboard a houseboat somewhere on the Broads. Three local children would include a twelve-year-old Principal Boy who would be the main thread of the story. His close allies would be a pair of sailing girl twins who crewed their father's racing dinghy. The other central characters were two sisters in complete contrast to the twins, being 'generally proper, careful gentle creatures but quite all right inside'. The 'Propers' were given names, Mary and Jane; an unimaginative choice since they were the original names chosen for the Amazon pirates. The three local inhabitants would be supported by half a dozen lads who would make themselves useful signalling, taking messages, etc. The action would take place in the spring and autumn with a term between.

It seems that, having abandoned his Swallows, Amazons and Ds, as he thought, Ransome looked at the possibilities of the fun to be had with the two town

children, home-educated to be very prim and proper, after they had been thrust into the company of a group of Broads children brought up to be web-footed and independent.

After Christmas Ransome wrote to Margaret Renold appealing for a plot. By that time he had given the book the title, 'Web-Footed Grandmother'. The spirited old lady was to be a widow and a painter in watercolours living aboard a boat, or possibly a houseboat on the Broads, and she sounds a little like his mother. Despairing of the way her great nieces were growing up, she invites them to come to stay with her.

Ransome had so much enjoyed creating Dick and Dorothea in *Winter Holiday* that in spite of his intentions to have no link to the earlier books, he pondered whether to bring them in somehow, but felt on the whole that it would be better to make this book completely independent. Dick and Dorothea were too close to his heart to be consigned to minor roles.

He was set on turning his Broads cruising experiences into fiction and he seemed to be relishing the challenge of using a completely true-to-life setting and real-life incidents. There were 'masses of things to happen … stranding on Breydon … voyage in a wherry … meeting with a Thames barge … shopping at Roys … night with an eelman … But main thread is still to find.'

At some point, the Old Lady, the Propers and the Principal Boy should set sail for Norwich or Beccles and somehow the Twins have to be left behind to follow in hot pursuit aboard wherries, tugs, barges etc. in a parallel narrative.

Finally, he needed to devise some sort of 'triumph' that his cast could achieve against the odds in order to provide the happy ending. It was important that this should be a collaborative achievement, otherwise he was afraid that the Twins, with their exciting wherry-tugboat-Thames barge pursuit, would steal the limelight from the Principal Boy and the Propers. At the same time, Ransome was determined that he must not allow the story to centre around the one central character of his Principal Boy in the manner of many stories for boys. This was too easy and would probably limit his readership. He wanted to give 'a fair share of the game for all the individuals, girls and boys'.

This handwritten note for an isolated scene would be developed and slotted into the rickety framework and eventually would energise the whole plot:

> Boy in canoe approaches ? houseboat? yacht? with someone on board (assuming that someone is known to him as the owner is), collars a heavy anchor weight, puts it in his canoe, sinks the canoe close by the moored yacht and himself hides among the reeds on shore. Pursuing motorboat turns up and inhabitant of yacht, willy-nilly makes accomplice. Explanations follow.

Work started on 'Web-Footed Grandmother' in late January. With no plot to guide him Ransome wrote a couple of scenes about Tom and the Bird Protection Society, one about No. 7 nest and another about Mrs Barrable and Tom. His first draft opened with his Principal Boy now given the name Tom and the locals have become the Coot Club:

Horning Reach
A misty morning seen from near to the fictional home of the Dungeon family.

Web-Footed Grandmother

Coots only

Tom waking in the *Titmouse*, a sort of *Coch-y-bonddhu* [The dinghy that was being built at that time for the Renolds] fitted with an awning over the boom, to make a cabin at night. He has been up the river to Colteshall, where he has been getting some brass screws and nails from a boatbuilding friend. He has spent the night above Wroxham, and now sails home through Wroxham, past many acquaintances, wherrymen, eel-catcher, boatbuilders etc. Birds, numbering off the known nests after leaving Horning, until he comes to the old windmill where he lives with his father (painter or poet?). [Ransome probably had 'Miller's Mill' in mind, a mile upstream from Horning Staithe, which was converted into a studio by the author A. C. Miller.]

Here he pulls *Titmouse* into a narrow dyke, all but hidden from the river, has dinner in the windmill, and in the afternoon comes down to a shed by the side of the dyke used for carpentering etc.

Presently the racing dinghies sail by all in a bunch and watching them lying hid he observes Port and Starboard and their father. Port and Starboard are wearing red handkerchiefs? Or otherwise letting him know without even glancing in his direction that when the race is over they will be coming to a meeting of the Coots ... Tom goes on fitting cupboards on the *Titmouse* ... The dinghies race back, Port and Starboard and their father in second place ... and presently P. and S. arrive by land at the shed above the dyke.

They report that they saw the others somewhere downstream … Tom reports all well with the nests higher up. The three pirates at eleven, approx. arrive very late, with the news that a motor cruiser has gone and moored close to No. 7 nest and won't move … Tom takes his old punt, not *Titmouse*, sends the others home to establish alibis, and himself goes downstream to deal with the cruiser. Terrific hullabaloo going on in the cruiser, all hands below. Wireless and gramophone going in the two cabins.

Tom gets their anchors, puts them on deck and lets the cruiser drift down with the tide. He himself paddles downstream so as to divert attention from upstream in case the cruisers attribute their casting loose to the three young pirates. The cruisers spot that they are adrift, catch sight of Tom and have a struggle to get engine going … Tom hears it started … What to do? … The houseboat. No sign of the pug who usually on cabin roof. Nobody there. No time to lose. Tom climbs on board…

On 6 March he told Margaret Renold that the book was 'too elaborate, and too thrutched up' and would not go at all. Help had been at hand for some time, as Evgenia had been urging the inclusion of Dick and Dorothea. What could be more natural,

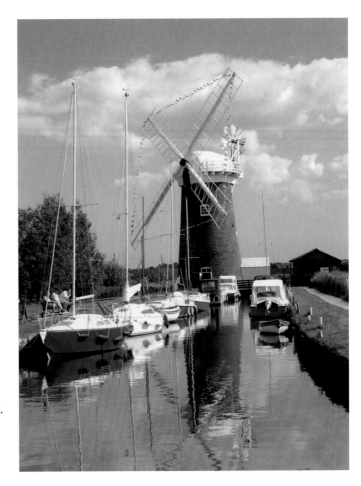

Horsey Dyke
The dog-leg dyke at Horsey leads to the fully restored mill that is in the care of the National Trust and open to visitors. Bunting has been strung between the sails of the mill to mark the Queen's Jubilee of 2012.

after the sailing sledge adventure in *Winter Holiday*, than that they should want to learn to sail? Finally Ransome stopped playing with the notion of his two prim and proper children who had by then become Prudence and James, and recognised the rightness of the suggestion. His first thought was that the Coot Club and Mrs Barrable, the Ds' grandmother, would have somehow become acquainted before they arrived in Norfolk. The plot continues:

> William [the pug] descends from cabin roof because clear that entertainment is over. Comes into cabin, finds old Mrs Barrable writing a letter, with painting things not put away. No sign of overdue tea. William, disgusted, goes ashore by the gangplank to go the round of a few treasure smells he has secreted on the bank behind the fringe of tall reeds … Mrs Barrable, drumming the penholder on her teeth writing to daughter Mrs Callum, complaining of stationariness of houseboat, telling of P. and S. whom whom she has seen when the dinghies raced past, being reminded of years ago when she sailed with her husband now long dead. No fun being moved by a man with a launch. Dick and Dorothea would learn nothing and it would be no fun for them. No one to pull them out of scrapes and tell them the names of the strings. Must just wait another year and she herself must go on staying put as if she were a hundred and two.
>
> Looking up from her letter and through the houseboat's forward windows she catches a glimpse of a boy in a punt paddling like blazes. Sporting instinct roused at once and she watches to see him pass saloon windows. No sign of him. A slight bump. He has climbed aboard the houseboat. He is lugging up her anchor weight from fo'c'sle hatch, and lowering it over the side. He lies on deck … Gurgle … splash. Boy jumps up and takes a flying leap onto bank. Sudden tremendous outcry from outraged William. Mrs Barrable goes on deck and calls him. William, unwilling, crosses gangplank. Noise of gramophone and shouting and motor. Cruisers come down river rudely shouting to know if she has seen a boy go by. She directs William's barking towards the cruiser and says no boy gone by as far as she knows. But that she was in the cabin. Cruisers barge on in angry pursuit. Mrs Barrable calls to boy. Tom thanks her, comes aboard and explains. Mrs B. very pleased with him. Asks if he can give her a hand now and then if she hires one of the small yachts. Tom says he thinks so but he must consult the Coots. He goes off upriver in the dusk, making sure that No. 7 nest is again all right, and the grebe again sitting on it … Mrs B. crosses out the last two sentences in her letter to Mrs Callum, and invites her to send Dick and Dorothea ? or to bring them with Mr Callum, involving another yacht????
>
> A few days later. Deliberation of Coots as to treatment of Dick and Dorothea. Mrs B. has been more or less adopted as a coot. Anyhow, friendly? Three pirates to meet the bus at Horning to help with the luggage? Or Mrs Barrable starts straight off at Wroxham and Dick and Dorothea come to it and head off to the houseboat. Probably better to houseboat. Port and Starboard carefully inspect them on the way. Tom takes Mrs Barrable home to houseboat. The pirates take the Ds and their luggage.

It is not clear why Ransome changed Mrs Barrable's houseboat for the *Teasel* but having done so, all sorts of possibilities arose. It is fascinating to 'overhear' Ransome as he pondered over possible ways in which his plot could be developed:

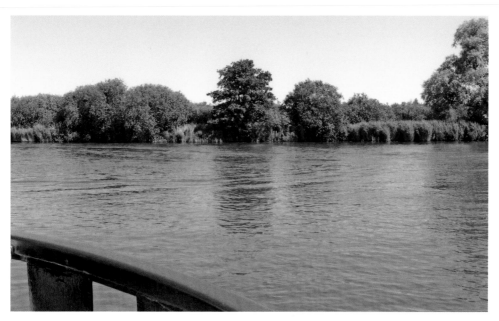

River Bure
The *Southern Comfort* leaves Ranworth Dyke. On the opposite side of the river is the place where Port pretended to collect swans' feathers to fool the hullabaloos.

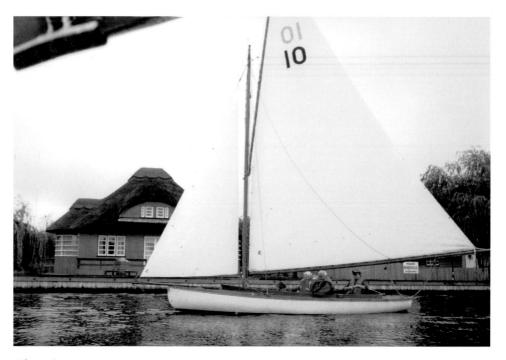

'Blue Wings'
Built in 1909, *Blue Wings* is one of the oldest surviving Yare and Bure One Designs, better known as 'White Boats'.

Adventures in the northern part of the Broads.

Visitors in small yacht dismast her against Ludham Bridge. Salvage by the pirates. Towed back to Potter Heigham.

Voyage to Hickling. Mooring in Heigham Sound. Bittern, bearded tits.

Voyage by Ludham to Stalham. The yacht. *Titmouse*. Port and Starboard. The pirates. Quanting. Dick overboard. ????

All the time Mrs Barrable hankering after voyage to Southern Broads, to Reedham, Beccles, Norwich etc. All going well with nests. Young birds in grebe's nests, etc. Tom free to come. Pirates to be put in charge as B. P. S. of the whole district. Port and Starboard say they can't come because it will knock them out of two of the dinghy races and so do their father out of his sailing. But they help in getting everything ready. Final provisioning, watering etc. at Wroxham. Port and Starboard say goodbye and go back to Horning, so that the pirates can crowd on board for the trip from Wroxham to Horning.

When Port and Starboard get home, they hear that their father is just off to London, so that he won't be racing for more than a week. They get permission to go with Mrs Barrable, pack their kitbags, and lug them down the garden to the water's edge just in time to see the flag of Mrs Barrable's yacht disappearing round the bend above the willows.

Despair. But the friendly wherry from Wroxham comes down the river on way to Yarmouth. The wherryman, hearing what has happened takes P. & S. aboard, sure of catching up the yacht at Yarmouth where it will wait a bit to go through at the turn of the tide.

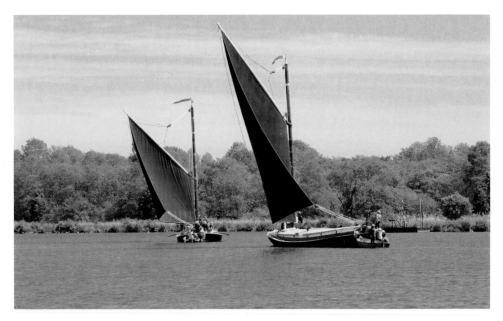

The Surviving Wherries
Albion with her sail reefed and *Maud* sailing in company on Wroxham Broad in the summer of 2012. (Courtesy of the Norfolk Wherry Trust)

But a terrible schemozzle of yachts and cruisers at Acle Bridge and by the time the wherry can get through already clear that they are going to be late for the change of tide. At Yarmouth they hear the yacht gone through long before. The little old chap who runs the motorboat takes pity on them and takes them aboard and up Breydon Water.

But water in the petrol. He gets held up on Breydon, is passed by a Thames barge. Comes to the junction of the Yare and Waveney where the pilot on the hulk there tells them that the yacht has taken the Waveney and is going to Beccles. The old chap pursues the barge and puts them aboard. They get on with the bargee and bargess. But night comes on and the barge ties up for the night. They are given a bunk in the cabin. Breakfast on the barge. Arrival in Beccles.

Finds Tom, Mrs B. and the Ds.

Or continuation of 'buts'. With the yacht having met them in the early morning and gone by and through the New Cut before the bargee went on deck, as he was waiting for a tide up the Waveney and they were using one coming down. In this case they get a lift on some other sort of boat and join the others somewhere up the Norwich river.

Ransome simplified the plot by omitting the journey to and from Wroxham for stores and rather than that *Sir Garnet* should be caught in a mix-up at Acle Bridge, Ransome simply allowed her mate to oversleep and delay the wherry's departure from Horning so that she was very late for her tide. There was no need for Old Bob's petrol to be contaminated, for the twins would be too far behind the *Teasel* making straight for Beccles. The twins aboard the Thames barge were the ones to go down the New Cut. Barge skippers and their mates were known as bargemen, and the term 'bargess' is a charming creation!

Meanwhile, of course, voyage of Mrs Barrable, Dick and Dorothea and Tom. Regretting the absence of Port and Starboard, but getting along quite well. Through Acle to Yarmouth. Hitting tide exactly. Tom towing them through bridges and under Breydon Bridge, coming aboard again to get the mast up while Dorothea tows in *Titmouse*.

They get to Beccles, go ashore in the town and send postcards to Port and Starboard. P. & S. on finding them send more postcards to themselves as well as to their mother. These however miss the post.

???? Horror of mother of Port and Starboard, wondering what on earth has happened. Enquiries made of the Pirates, who of course know nothing, but at once set off downriver to look for them. Or not at once, the next day before the news reaches them that P. & S. are all right and with the others??? They get down to Yarmouth and so come in for the salvaging of Mrs Barrable etc. who went aground at high end of Breydon. ? Isn't this a bit thick and involving too many passages through Yarmouth, thus lessening the terror that should accompany that act???

Mrs Barrable and the Ds get aground at high water in Breydon while Tom is getting milk. They want to get round from Yare into Waveney, but get bothered by fog, go hunting for the mark posts and slipping out of the channel get hard on the mud. Not know what to do. Tom comes looking for them. Water already fallen too far. When he finds them he can't reach them. The noble William is used as a means of getting a line

across the mud so that the *Titmouse* and the yacht can exchange grub, milk etc. Poor noble William is very muddy. Gets back to yacht where, carefully washed and dried and given warm ovaltine.

This episode was hardly changed in the final version and was one of the first to be written. The pug dog William belonged to the Renolds and in *Coot Club* Ransome presents an endearing portrait of a proud and fastidious little dog that finds the ways of humans puzzling.

The yacht has driven ashore on the top of the tide and when next day the tide does not rise quite so far they are still stuck fast. Finally the pirates arrive in their own old boat, turn salvagers and with their help, using a halyard from the top of their stumpy mast to haul the yacht over, all of them working together manage to get the yacht back into deep water.

This 'triumph' meets the aim of collaborative achievement and Ransome would surely have enjoyed describing the salvage operation in detail. A decade later he was planning a similar united effort to salve Captain Flint's houseboat on the lake in the north in the unfinished thirteenth novel. On another page Ransome made a short note that changed the entire character of the book:

> I think perhaps the same motor cruiser with crowd of hullabaloos should wander in and out from chapter to chapter, so that there is always a danger of Tom being recognised by them. This would give a sort of feeling of outlawry to Tom and to a lesser degree to the three pirates.

This was a stroke of genius. Once Ransome had decided that the hullabaloos were not the sort to forgive and forget, the casting adrift would set off a chain of events that introduced the tension that the plot needed. Four amusing incidents were slotted in – the mistaken identity on Horning Staithe, the disappearance into Ranworth Broad when coots and foreigners had just come together and the hullabaloos were tricked into looking the opposite way, the twins' last-minute rescue of Tom under the very noses of the hullabaloos and the pyjama-clad dawn escape from the hullabaloos at Potter Heigham. Slowly the plot began to come together:

> Mrs Barrable, playing up to this and really wanting peace and quiet at the same time, starts the idea of lying hid, and they secrete themselves say in a corner of Salhouse [Broad] by the unused entry, the pirates bringing news and they dodging into Wroxham for supplies when they know the coast is clear.
>
> Finally ???where??? the Pirates, as salvagers, happen to be in at the accidental sinking of the motor cruiser (which has possibly rammed a post on Breydon or Hickling or a collision). Anyhow complete reversal of position, the Hullabaloos appealing for rescue, and the Pirates very properly letting them wait, the cruiser's deck being only just below water, while they salve the damaged sailing boat (if after a collision), the Hullabaloos crowd into the Pirates' boat, try to take charge but get suppressed by the rescued from the sailing boat. Or in some other way the Pirates make a good job of the salvaging, laying out

anchors etc. So that the owner of the cruiser rewards them by giving them for themselves
an old sailing boat with a cabin????

Tom's outlawry provides the motivation for the pirates' long voyage south, as they
try to reach him in time to warn him that the hullabaloos know that he is aboard
the yacht and are on their way. Eventually, Ransome decided the hullabaloos should
strike a beacon post just after they had sighted the stranded yacht on Breydon. The
yacht is towed back to Yarmouth against the tide by the old man in his tug, with the
hullabaloos crowded aboard the pirates' boat at the end of the tow-rope. Once the
sodden hullabaloos have been put ashore, both boats are towed to Acle, so that they
can sail on to Horning in time for the twins to race with their father the following day,
bringing their cruise to a satisfying end.

Once their Broads holiday was over and they had spent a few days in London,
Ransome wrote practically every day for three months.

At the end of June he had several attempts at rewriting the start. Eventually he decided
that the Broads should be seen through the eyes of the Ds as much as possible (as he
had with the lake country in *Winter Holiday*) and this meant bringing them in from
page one and re-arranging the whole beginning. Readers may have wondered why the
evocative drawing *First Night in the* Titmouse should be used as the frontispiece. No
doubt the drawing was made before he abandoned the opening chapter and Ransome
liked it too well to consign it to the waste paper basket.

Ransome was now working more intensively than with the earlier books and
thinking of little else. All through the summer the little *Swallow* lay moored at Bowness
while her skipper struggled to pull the book together. By August the effort was taking
its toll on Ransome's health. This worried Evgenia and the daily chore made them both
miserable. When Ransome read through the first draft in the middle of July, his verdict
was straightforward: 'Too solid. Not enough dialogue.'

He continued revising throughout August, with Cape fretting over the delay in
getting their hands on the manuscript. *Swallows and Amazons* had been published
in the summer, but Jonathan Cape wanted the others to be in time for the Christmas
market. The typescript of *Swallowdale* had gone to the printer at the end of July, *Peter
Duck* was off Ransome's hands in early August, while *Winter Holiday*, which had
given so much trouble, was finished by the third week in August.

Some of Ransome's difficulties were created by his attention to detail and insistence
on accuracy. He wrote to the London and Rochester Trading Company to make sure
that *Welcome* carried the right cargo and he also wanted to know whether it was
standard practice to use the New Cut. The company replied that it was and that their
barge *Pudge* carried wheat to Beccles and returned from Cantley with malt or beet.
Ransome did deviate from complete accuracy when he maligned the good people
of Yarmouth by introducing a gang of wreckers operating along the lower Bure,
presumably in order to heighten the hazards of passing through Yarmouth, for there is
no record of any such nefarious activities.

Finally, in desperation, Wren Howard of Cape told Ransome that the typescript
must be with them by first post on Saturday 1 September, which meant posting the

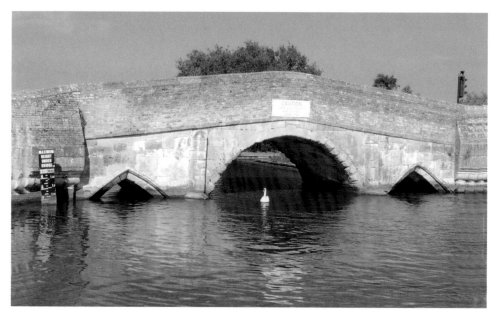

Potter Heigham Bridge
The bridge with its maximum headroom at the centre of 7 feet keeps the upper reaches of the Thurne, Hickling Broad and Horsey Mere mercifully free from the largest motor cruisers.

Margoletta
There are very few wooden motor cruisers of the size of *Margoletta* to be seen on the Broads these days. This example was moored in Horsey Dyke in 2012.

following day. He had just finished the second draft of 401 quarto pages, but he had no intention of letting it go. There were still far-reaching changes that he felt were necessary, including yet another re-write of the opening chapter. Moreover the book was too long and he needed to prune some fifty pages. At the last moment he decided to change the name of Mrs Barrable's yacht from *Daisy* to *Teasel*. It was too late to change the name on the jacket that had already been printed.

Somehow, he managed to persuade Howard to extend his deadline by a further week, but with four days to go Ransome gave up. Evgenia had been telling him for some time that it was not fit to publish as it was. He told Cape that *Coot Club* would not be ready that year. The whole thing needed to be put aside for a bit so that he could see what was wrong.

There was consternation at the publishers. The book had been announced in the trade papers and to their agents all over the world. The orders had come rolling in and the printers had put aside their special paper in order to print 4,000 copies. Howard wrote a no-nonsense letter saying that delay would be dangerous, harm sales and disappoint his fans, and it would be much better to send it as it was regardless of his concern, and Evgenia's opinion (which he considered hypercritical).

The day that he received the letter Ransome returned to work, and he sent the finished typescript direct to the printers in Edinburgh shortly afterwards, giving Howard no chance to see the final version before it was set in type. It is not difficult to see both points of view: the plot does seem a little awkward, yet Howard saw that even if it had not reached the standard that Ransome demanded of himself, it was a very fine story as it stood, and one that introduced a new dimension to the Swallows and Amazons books.

There followed a further rush to complete the pictures. Cape wanted the usual twenty full-pagers and numerous tailpieces. Fortunately, Ransome found these much easier than he had when drawing snowy scenes for *Winter Holiday*. He was always more confident when it came to drawing boats ('All sailors can draw ships', John Masefield encouraged him) and he was able to copy the useful Broads photographs that he had taken during the visit in May. Even so, he covered seventy-three pages of his sketchbook with preliminary drawings, before starting on the inked versions. When Ransome travelled to the printers in Edinburgh at the beginning of November in order to check the proofs on the spot so as to save a day or two, it seemed as if the book would never be ready in time, yet three weeks later he was handling the advance copies and fuming over the errors.

Coot Club was an instant success. 4,000 copies quickly sold out and there was a hasty second printing. By Christmas, more than 5,000 copies had been sold – the best yet!

It is interesting to speculate on what changes Ransome might have made had he been able to do so. Would he have substantially reduced the length as he intended? The only chapter that might have been cut is 'Lying Low', in which three days occupy a little over ten pages. *Coot Club* is a restless book, always on the move. Ransome wisely omitted the adventures at Ludham and Hickling and instead gave Tom, Mrs Barrable and the Ds the quiet days aboard the yacht while Tom lay low in Ranworth (Malthouse) Broad.

Above left: Titmouse
The *Titmouse* that Harry Dimbleby sailed in the BBC adaptation of *Coot Club* is stored at Hunter's Yard. The shed with the boat under repair, stacks of large mahogany boards and vintage tools on display is a Mecca for wooden boat enthusiasts.

Above right: Teasel's transom
In a corner of the shed is the false transom fitted to *Lullaby* for her role as the *Teasel*.

Ransome's fans might regret the last-minute axing of the story of Tom's first night under the awning, for his knack of making ordinary acts interesting, as well as his ability to create atmosphere, would surely have made it a fitting introduction to the pleasures of the Broads.

Coot Club was the first in the series in which the children are not playing games. The Coots are a thoroughly decent group of youngsters, children of boatbuilders, a doctor and a solicitor, and brought together by the fellowship of the river. In springtime they do their best to live up to the aims of their Bird Protection Society. The Death and Glories may have taken turns to play truant from school in order to keep a watch on their special coot, yet as boatbuilders' sons they are shocked when Tom sets the *Margoletta* adrift. 'Did you oughter 'a done that?' asks Joe. In spite of their solicitor father, the twins' code is less strict. 'Good', says Starboard, and that is that. To the Coots, Mrs Barrable and the Ds may be 'foreigners' but there is none of the Swallows' condescension in *Winter Holiday*, when Roger is rude, John patronising and Susan unsympathetic. At the end of the book, although he did not have to do so, Tom apologises to the hullabaloos because he has put himself in their place for a moment and realises that it is the right thing to do. There is solidarity among the Norfolk folk caught up in the *Margoletta* affair. When the hullabaloos advertise a reward for information, *Sir Garnet's* skipper Jim Woodall reflects, 'If a Norfolk boy done it, those chaps can cover the place with paper before anybody give him away.' This unity makes the treachery of the odious George Owdon all the more contemptible.

Enthusiasts are always ready to speculate on the origins of the characters, places and boats in the Swallows and Amazons books, and *Coot Club* is no exception. The character of Dr Dudgeon, who had ministered to Mrs Barrable's brother Richard after he had cracked his skull, may be a tribute to Dr Bennett of Wroxham who had looked at Ransome's battered skull and had been kind to Evgenia after she had hurt her hand. The old tugboat skipper of the *Come Along* at Yarmouth seems to have been inspired by 'Old Burbar', who had towed the *Fairway* up through Yarmouth.

The Norfolk folk – Tom, Port and Starboard, Joe, Bill and Pete – appear to be entirely original creations. Mrs Barrable, the amateur painter, sounds rather like Ransome's mother and to complete the identification she appears to be a widow. Ransome always liked to know more about his main characters than he let out, and various working notes supply the information that Tom Dudgeon was aged twelve or thirteen, Pete was nine, Bill ten and Joe eleven at the time of *Coot Club*.

Ransome's passion for the authenticity of *Coot Club* extended to the sailing times. He took such care that in order that he should be correct in the time it would take Tom to sail from Ranworth to Wroxham, he sailed in a dinghy from Horning Hall Farm to the windmill above the ferry and back. From this he deduced that Tom would take three and a half hours to reach Wroxham if he rowed whenever he could not run or reach, and from this estimate he carefully plotted the complicated course of events. Assuming that Tom left Ranworth at 8 o'clock he would be at Wroxham by 11.30 a.m. Allowing an hour to change the battery he should be sailing down Nelson's Reach at 3.30 p.m. If the Ds left at 1.30 p.m., and rowed gently until they were passed by the *Margoletta* half an hour later, and from then on rowed as hard as they could, they should be at Horning Staithe around 2.45 p.m. Pete and the Twins could be off by 3 o'clock. Pete on his bicycle would be back by 3.30 p.m., by which time the *Margoletta* would pass the staithe and the encounter would take place around 3.45 p.m.

One question concerning *Coot Club* remains. Most of the dedications of the Swallows and Amazons books were to friends known to have played some part in the book's creation. The dedication in *Coot Club* reads, 'To the Skipper of the *Titmouse*'. The best guess that I can offer is that he discovered that Dr Long was a sailor. The owner of a craft called *Titmouse* would have been knowledgeable about birds to have used the full name, as it is rarely seen in bird books and when it does it usually appears as 'titmice'.

It is quite clear that Ransome's motivation for writing *Coot Club* was to capture the essence of the Broads. Thanks to his scrupulous accuracy and at times an almost poetic response to landscape (particularly in the chapter 'While the Wind Holds') he succeeded, and his contribution to the social history of the region becomes more valuable with the passing years.

The 1930s were a time of change. There were many more signs of the vanishing way of life that grew out of the distinctive wetland area. The average marsh farmer eked out his livelihood by keeping a few cows, pigs and hens but could turn his hand to eeling, helping with the reed- and sedge-cutting and doing a little wildfowling. The boatyards were still family concerns, run by the man whose name they bore, with boats stored in dykes that had been dug by hand. Some were quite small concerns, for example as late

as the middle of the 1950s, Horning's Ferry Boatyard had one five-berth cruiser, three four-berth cruisers, two three-berth cruisers, four two-berth cruisers, one two-berth yacht and three houseboats for hire. The 'development' of the Broads would change all that. Within a few years of *Coot Club* the wherries would be gone, the banks that had been kept clear of trees, so important to the wherries' engineless progress, were starting to sprout and in the years ahead motor cruisers would pollute the rivers and bring down the banks with their wash.

More than meticulously recording, Ransome championed the environmental cause at a time when only a handful of naturalists were aware of what was happening to the area. So when the Broads were attracting more and more holidaymakers Ransome raised his voice and pointed out that the wildlife mattered. Visitors from towns and cities spending their annual holiday on the Broads and looking for a good time were all very well, and good for the local economy when the traditional way of life was declining, but there was a price to be paid, and just as the Lake District was in danger of being 'loved to death' so the Broads were being threatened by overuse, ignorance and complacency.

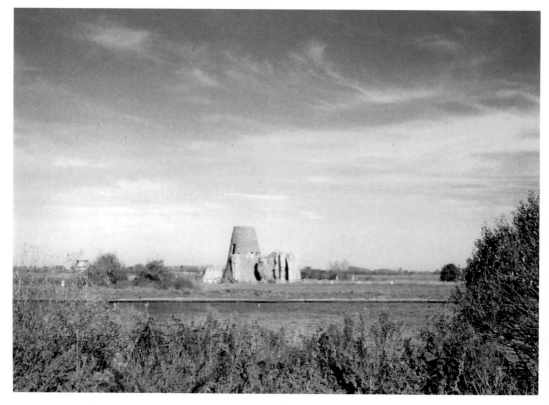

Bure Landmark
The ruins of St Benet's Abbey seen from the overgrown mooring once favoured by Arthur Ransome.

7

'Barnacle Bill'
1938–9 Cruises

Made restless by their newly acquired financial security, in the spring of 1935 the Ransomes began to look for a suitable property in East Anglia with the intention of owning a sea-going yacht once more. Their new home was across the River Orwell from Pin Mill, and by the time that they had completed the move in the late summer of that year, Ransome was the proud owner of a 7-ton cutter that he renamed *Nancy Blackett*. They quickly became members of the thriving sailing community at Pin Mill. In the summer months they would sail around the anchorage distributing bunches of flowers from Evgenia's garden to their friends. Their near neighbours at Broke Hall were the Russell family and although the parents were not at all interested in sailing, Their teenage children, George and his younger sister Josephine, were always ready, when school holidays permitted, to sail with him. They became staunch allies, and very useful ones, because Evgenia despised *Nancy Blackett*'s galley and was a reluctant and critical crew. There was also the Busk family, the colonel, his wife and their three children to whom *Secret Water* was dedicated. They sailed in company with *Nancy Blackett* in their yacht *Lapwing*. There were also the four 'buccaneering gun-firing' Youngs from Maldon (the brewing family) and the young Arnold Fosters who lived at nearby Nacton.

During the Easter holidays in 1938 Ransome hired five *Fairways* for a week's cruise with his teenage friends. On the face of it this was a strange act for a man who claimed that he disliked children and who had taken Cape to task because they had suggested that he wrote for teenagers. Yet Jill Busk, who had often sailed with Ransome at this time, told me how easily and naturally he spoke to children. Once she put *Selina King* on the mud near Ipswich and he could not have been nicer. Josephine Russell always insisted that he was a wonderful skipper who never raised his voice and always explained carefully in advance what he expected his crew to do. Not everybody agreed. Philip Rouse had been a contemporary, at Rugby. His son Clive told me how one day he had been left in charge of *Nancy Blackett* aged ten, while Ransome went below to tinker with the engine. Ransome had set a course to take *Nancy* in a wide circle in the Orwell, but by the time he emerged, the course had taken them out of the main channel and they were heading towards the mud. Although Clive had been careful to do exactly as he had been told, Ransome, rather unfairly, blamed the youngster, who found him rather alarming in consequence.

Was it Jack Powles who put the idea into Ransome's head to take his fleet of young friends touring the northern Broads in 1938 and again in 1939? A scheme that Powles had started in the mid-1920s made it possible for fleets of schoolboys to take holidays

on the Broads in yachts skippered by university men. The Venturers Easter Cruise was started in the late 1930s. This is a Christian holiday for twelve- to seventeen-year-olds aboard a fleet of yachts, and today it is as popular as ever. A few years ago I was lucky enough to join the Venturers briefly for a sail on Barton Broad and saw at first hand what a Ransome-like time the youngsters were having. Ransome was a stickler for sailing correctly and he would have thoroughly approved.

In a draft for his autobiography, Ransome had this to say of his young pirates:

> The average age of the skippers in charge was extremely youthful, and most of them were very efficient. It was a condition of coming on this expedition that each boat must have her own Jolly Roger, so that in case of separation, we should be able to recognise our allies at a distance. On the Broads, where the waterways are often above the surrounding country, it is possible to see the white sails of boats miles away, and we thought it well to be sure of knowing our boats from others if one of them failed to reach in time for supper the rendezvous chosen for the evening. I suppose the mothers made the young sailors' flags. We told them, 'A black flag with a skull and crossbones', gave them the size and left the details to them. They were good flags, though none quite so good as the beauty that Genia made for ourselves. I remember particularly a flag made for the Youngs. Mrs Young was not sure whether skulls had teeth, and, just in case they had she provided hers with some large ones. The stitching was not too strong and while the skull and the black flag rippled in the wind, the teeth rose and fell like clappers and delighted us all.
>
> There were, I think, five and a half immersions, due in every case to admiration of these flags. Our sailors standing on their narrow decks and looking up to see that their skulls and crossbones were properly displayed, used to take a step or two to get a better view got a bath instead and were presently sailing with clothes as well as flags in their rigging.

Much to her disgust, Josephine Russell's mother put her foot down and refused to let her go with her brother and their cousin Raymond. The three elder Young boys sailed alone, while Roger, the youngest, sailed with his parents. The fifth *Fairway* was sailed by the Arnold-Foster family. There was also a tiny *Whippet* from Collins' yard at Wroxham that was in the capable hands of Taqui and Titty Altounyan, who had been to school in England and were now aged twenty-one and eighteen.

Raymond Hubbard was fifteen and knew nothing of sailing when he crewed the *Fairway* that year. He thought that Ransome, with his beret pulled well down and puffing away at his pipe, was a wonderful mentor to his rather novice fleet. He helped the newcomers to set their sails, suggested reefing if he thought it would be advisable, and if he saw them doing something risky, he would signal by waving his arms like a windmill. He was always kind, patient and good-humoured as well as entertaining with his fund of Anansi stories and shanties played on the penny-whistle. Evgenia reminded him of a kindly school matron with her concern for their comfort and cleanliness. Her attitude towards her husband seemed to be rather different, for the piercing blasts on her whistle would make him start and hastily report for duty. Both Ransome and Evgenia wore brown berets when afloat in such a way that they reminded Josephine Russell of Christmas puddings.

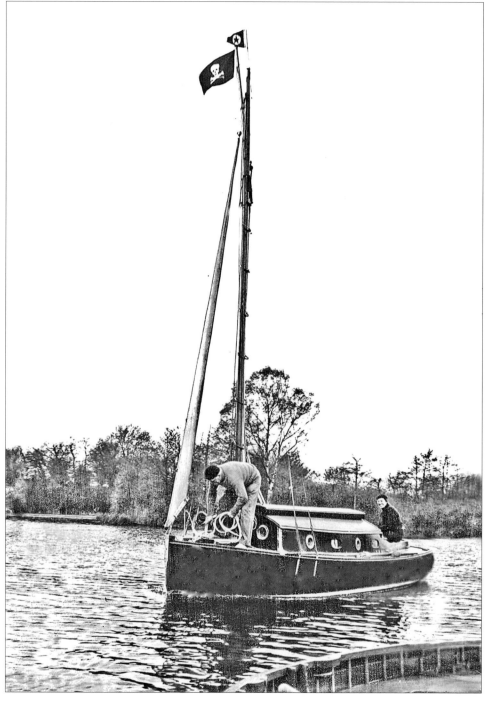

Fairway
The Ransomes join the rest of the fleet at their chosen mooring. (Courtesy Leeds University)

Ransome does not appear to have kept a log of either of his final Easter cruises and made only the briefest of notes in his diary. George Russell kept careful logs of the cruises and these records capture something of the spirit of those carefree days on the Broads just before the outbreak of the Second World War that would claim his life.

On 7 April Ransome had to tear himself away from Harry King's boatyard at Pin Mill where he had been carefully recording (and fretting over) the construction of his new boat, in order to join the rest of the crews that had gathered in Wroxham. It was standard practice to give new hirers a short trial trip and George and Raymond were taken out by one of Powles' boatmen, and apart from bumping their dinghy, all went well. Soon afterwards they were away and with a very light north-westerly wind entered Wroxham Broad at the head of the fleet. Clearly, Ransome had confidence in the young skipper, for he and Evgenia stayed behind helping others.

George hung about waiting for the Ransomes, and then when they did not arrive their impatience got the better of them and they sailed on until the wind failed completely. Ransome had to send Thomas Young after them and rowing together in the dinghy the boys towed the *Fairway* back to the rest of the fleet, who were moored just below the south entrance.

When they finally arrived, they found that everyone else had nearly finished stowing sails and making ready for the night. After a little while Evgenia came on board to show them how to use the Primus so that they were able to heat their tomato soup to have with the pressed beef and paste sandwiches. Ransome had been busy going around checking that all was well aboard and helping the novice Arnold-Fosters to stow their sails and he popped in for a moment in the middle of their supper and explained that they themselves had not yet eaten. He left abruptly at the sound of Evgenia's whistle, and after rowing around the fleet, George announced that Raymond was to be responsible for making out the necessary shopping lists and menus while he would be responsible for keeping the log.

It being their first night afloat they awoke around 5 a.m., and so after reading for an hour, George went into the well and made a pot of tea. Then he went on deck to hoist the pennant, feeling very superior to the Arnold-Fosters who had left theirs up all night. They managed fried eggs and bacon, and while they were washing down the topsides, Ransome arrived with the pulley so that they could run the Jolly Roger to the peak.

The wind was stronger and Ransome instructed the fleet to reef as a precaution, although he did not do so himself as he led the way downriver to Horning, where they welcomed the others with chocolate bars. Once underway, George found, like others before him, that the jib was now too large and it prevented the head from coming round, with the result that he rammed the bank twice. By the time they were sailing down Horning reach, he had discovered that if Raymond let the jib sheets fly before going about they had no problem and to their delight they outsailed the Arnold-Fosters, who had abandoned theirs.

They moored outside the Swan, after which they all had ginger pop at the Swan. Each crew took the opportunity of filling the water tanks at the pump on the green and George sent a card to Josephine, after which they raced Titty and Taqui to the Horning Hall Farm mooring. Once they had all completed their 'harbour stow' to 'Barnacle Bill's satisfaction, the Arnold-Fosters invited them for tea. Later, George went for a walk up the dyke to the farm and was intrigued to discover a medieval chapel in use as a barn.

The Jolly Roger
Evgenia's Jolly Roger that they flew on the Broads as displayed at the Museum of Lakeland Life and Industry, together with his swallow and scarab flags flown from his dinghies.

Thurne Dyke
Two small members of the crew of *Perfect Lady* waiting to board. The Lion Inn can be seen through the trees at the head of the dyke.

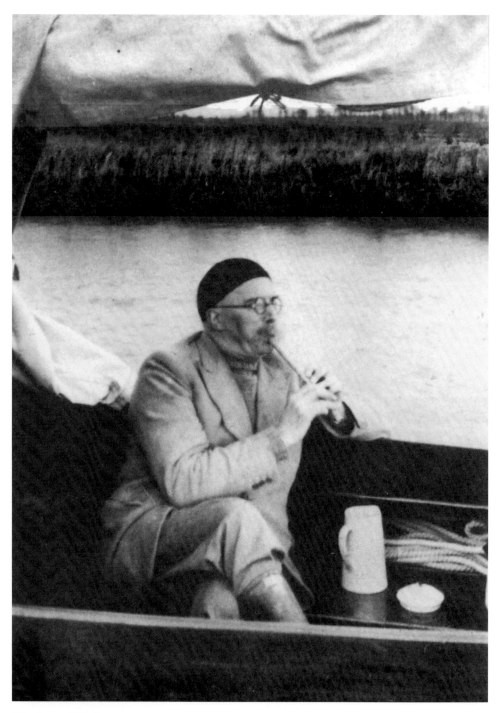

The Penny Whistler
Arthur Ransome keeping well out of the way while Evgenia prepares their evening meal.
(Courtesy Josephine Russell)

Their supper that night consisted of pressed beef, tomato soup, lettuce and chocolate biscuits. It was early in the year and the evening was cold, so after washing up George went for a sharp row in the dinghy to warm himself up before going to bed.

The boys had a better night, having discovered the knack of making up their beds and so did not wake until eight. Ransome called a conference of skippers and it was decided that the they, Titty, Taqui and the boys should make for Potter Heigham, the young Youngs should try to reach Ludham Bridge and the Arnold-Fosters and Roger Young and his parents would remain where they were.

In the event, the boys never left the mooring either. As he was helping Titty and Taqui to get away, George fell in and was ignominiously hauled out by Evgenia and Raymond. He quickly changed into his spare pair of trousers, but worse was to come, for as he was rushing to set sail his glasses went flying overboard. There was no chance of sailing to Potter Heigham now, so he took his wet trousers to the farm and set about making some sort of dragnet.

Finding their dinghy was missing an oar (captured, no doubt, by another pirate) they borrowed one from the Arnold-Fosters. With proper schoolboy etiquette the culprit is never named in the log. An unsuccessful search ended when he was almost swamped by a large motor cruiser that had not realised he was anchored by a mudweight. George missed his foothold on the bank and landed in the river a second time.

That was the end of dredging operations and George had to borrow Raymond's spare trousers. The boys had a hasty lunch and afterwards took another pile of wet clothes to be dried at the farm. They made their way up to Ludham Bridge in order to telephone Mrs Russell and to buy some more food.

After tea, they walked up to the bridge again so that George could meet up with his mother who had driven up from Ipswich with glasses, vests, pants and a spare pair of plimsolls. There is no hint in the log of what Mrs Russell felt about this start to her son's holiday! The boys called at the farm on the way back and found that the clothes were not yet dry. Soon after 8 o'clock it began to rain so they settled for an early night, hoping for better things the next day.

In the morning, after a hurried breakfast and with George once more in his own trousers, they set sail for the Thurne. This time Ransome waited to see them safely away, although almost at once the boys' *Fairway* crashed into the concrete bank but fortunately it was the metal stem that took the force of the impact.

They had an uneventful sail to Thurne Mouth, where once more they overtook the Arnold-Fosters. However, once they were heading into the northerly wind up the Thurne they had the greatest difficulty in making any progress and were suitably mortified when the Ransomes sailed past them and were the first to arrive at Thurne Dyke. Taqui and Titty had not stopped at Thurne and were heading for Potter Heigham, while the Youngs had gone into South Walsham Dyke and arrived later.

Everyone except the girls, who had not returned, gathered at the Lion Inn and George and Raymond spent a profitable ten minutes playing on the penny-in-the-slot machines. After lunch the fleet set off for Potter Heigham to meet up with the waiting girls. George and Raymond had a dreadful time of it trying to tack up against the wind in the congested reach between the bungalows and Raymond had to tow some of the way.

River Bure
The well-wooded banks of
the Bure were more open in
Arthur Ransome's day.

Arriving at the bridge they found that the young Youngs had already gone through. George and Taqui went to view the bridge at close quarters and decided that they would try to go through straight away rather than waiting for the next morning. It was not as difficult as they had feared, although it was 8 o'clock before they were safely through and had the masts up again. By then the Bridge Hotel had stopped serving food and so the girls joined George and Raymond for a communal supper, and after sharing the washing up they all went to bed, tired out.

Ransome had moored below the bridge, and while the others were at breakfast he towed through. The day promised well as they had awoken to bright sunshine, and he decided to get underway as soon as possible. Finding that Raymond had forgotten to buy stores the day before in all the excitement of going through the bridge, Ransome marched him off to the Bridge Stores. While they were gone, George recruited the help of David Young and together they managed to retrieve the pulley that George had accidentally sent aloft while fumbling with the ropes in the dark the night before.

It was after eleven before the fleet finally set sail into the same northerly wind as the previous day.

This time Ransome led up the river, followed by the Arnold-Fosters and then George and Raymond. They continued in that order until they reached the mouth of Kendal Dyke when the Arnold-Fosters were passed again. Once in the dyke it was a different matter, and after they had failed to tack up, Raymond had to tow through. With both the Youngs' boats having caught them up, the five *Fairways* swept across Whiteslea with Ransome well in the lead. A lucky puff of wind sent the boys into second place as they entered Hickling. At first George was careful to keep near the posts marking the channel, but in trying to be clever and save a tack, he left the channel and went close to the shore while, at the head of the Pleasure Boat Inn, Ransome watched helplessly and waved his arms like a windmill in an unsuccessful attempt to attract the boys' attention.

The *Fairway* stuck fast, held by the rudder. There was nothing for it but to try to pole off with the quant. This proved successful, and they returned to the main channel, trying to look as if nothing had gone wrong. There is no mention of what the school-matronly Evgenia had to say about such disregard for the morning's briefing.

They visited the Pleasure Boat Inn and bought ices that they ate with their picnic lunch. Returning across Hickling, the fleet was much more organised and they sailed back one behind the other, 'in line ahead'. They were reminded of the realities of life in the wider world when their peaceful crossing was shattered by a bomber that flew across very low over the broad – not a silver aircraft, which they were used to seeing in the sky, but one painted with wartime camouflage.

In Kendal Dyke the boys' *Fairway* had another bad bump, again fortunately without any damage. They returned to Potter Heigham in company with the elder Youngs and once more successfully negotiated the bridge. Here they tied up while George visited the stores for postcards and the badly needed methylated spirits that they had forgotten that morning. The fleet moored in Thurne Dyke for the night.

At 7.45 that evening, George tried to ring Wroxham post office to ask them to send their letters to Horning, but not surprisingly he failed to get through!

It was, he recorded, 'a perfect day' with a good wind, brilliant sunshine and a spectacular sunset. The only drawback was that almost everyone had been badly sunburnt.

The temperature plummeted once it was dark and it was a bitterly cold night with a heavy frost. Next morning, after an early start to their day, Raymond successfully telephoned to Wroxham. The other pirates made a more leisurely start and it was almost 11 a.m. before they were all away and George and Raymond became engaged with an 'unintelligent' hullabaloo. Once at Thurne Mouth, they turned down river, finally stopping at Acle Bridge where they tied up alongside the Youngs and watched in amazement as several yachts successfully 'shot' the bridge in the manner of *Sir Garnett* in *Coot Club*. Then both boats rejoined the rest of the fleet for lunch beside Upton windmill.

Here they planned and successfully carried out a plot to photograph Ransome as he was starting up on hearing his mate's whistle! After lunch when they were heading for Horning, the *Fairway* was humiliatingly passed by a much larger yacht. By now the wind had dropped and so they decided not to try for Horning but to have a look into Malthouse Broad instead, where they became birdwatchers and observed several grebes and came close enough to a heron to see all the details of the head.

As soon as they turned to tack towards the dyke the *Fairway* went aground. Early efforts to re-float only made things worse and the *Fairway* refused to move until they managed to synchronise their efforts. Raymond in the towing dinghy rowed as hard as he could while George pushed at the quant with all his might. Once in the dyke, they changed places and George towed until they reached the river and they could sail. Unfortunately they had failed to make fast the dinghy properly and had to go back and pick it up, with the result that they were late rejoining the fleet at their mooring for the night at Horning Hall.

Once all was properly stowed, George rowed Evgenia to Ludham Bridge where he filled up with water and she went shopping. Arriving back they found that the 'Whippet Post' had arrived. Titty and Taqui had managed to reach Horning where

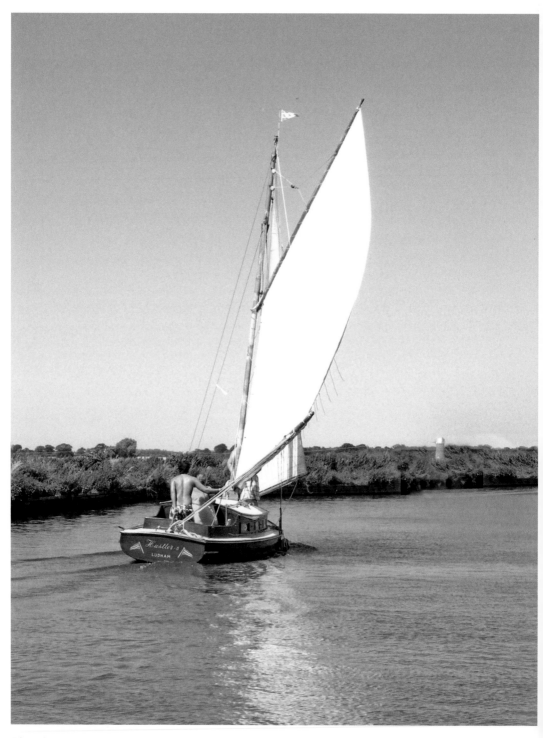

River Ant
On a hot but blustery morning the crew of *Hustler 3* wisely took in a reef at Ludham Bridge before sailing for Barton.

they picked up everybody's mail. Titty had inscribed each envelope with a 'Whippet' postmark. By this time her interest in sailing was waning, but as Taqui was very keen and could hardly sail alone, she went along and tried to be as 'Tittyish' as possible to please her 'Uncle Arthur'.

Evgenia invited the boys to supper and so they were able to laze around until they heard her whistle. That evening they fed on cold tongue, hot potatoes and tomatoes, followed by plum pudding laced with rum!

Their last full day began with a series of accidents. It had been arranged that they would meet up at Horning Staithe for lunch so as to be within easy distance of Wroxham if the wind should fail. The Young boys were away first but lost their mainsheet overboard, much to the raucous amusement of their parents. Titty and Taqui were off without incident, but in helping the Arnold-Fosters Ransome all but went in the river, and then he had to make two attempts himself to get away, much to his annoyance.

The north-westerly wind was coming in gusts and the elder Youngs waited to put in a reef. George and Raymond got away with a full mainsail, very nearly charged the bank as they did so, and spent the first couple of miles wishing they had also reefed, but later as they began to approach Horning and were blanketed by the trees they were glad they had not.

When they came to Ranworth Dyke they made a point of carefully looking out to starboard rather than be reminded of their shame of the day before when their dinghy had been left behind. At Horning Ferry they passed a wherry loading reeds. In the next reach they came upon Titty and Taqui trying to overtake the same large yacht that had passed them the day before. At least six yachts were sailing up the mile-long reach towards the staithe, and much to their delight, the boys overtook the large yacht while she was becalmed and so they followed the girls up to the staithe. Here they were almost rammed by a large wherry yacht opposite the Swan before mooring under the eagle eye of 'Barnacle Bill'.

They went ashore for some last-minute shopping and Raymond took a fancy to an incredibly friendly goose while George saw to it that he was on hand to help an elderly lone sailor to moor his little ship. Lunch was followed by a period of quiet relaxation during which the boys dozed. They came to to find Titty and Roger, the youngest Young, had been in the river. Roger, busy with his ice-cream and without his life-jacket, had quietly slipped overboard between the boats. Titty alone had seen him go, and snatching off her glasses, went in after him.

'I couldn't help it,' the dripping wet Roger explained and then demanded, 'Where's my choc-ice?'

Evgenia saw to it that rescued and rescuer were properly dosed with medicinal rum.

Ransome noted prosaically in his diary, 'Horning. Roger and Titty o.b.' and when he came to tell the story for his autobiography, Evgenia replaced Titty as the heroic rescuer.

It seems that when peace had been restored the girls were challenged to a race by an identical *Whippet*, with Evgenia acting as starter and George the official photographer.

In spite of this interest he makes no mention of the outcome of the race, during which the other crews made for their first mooring place near the south entrance of Wroxham Broad, doing their best to keep out of the way of the racers.

Once on the broad, Titty and Taqui, both the Youngs' boats and George and Raymond sailed in company and in hoisting their flags, two of them went overboard, but George omits to say which two! They were rescued by a couple of local lads in a sailing dinghy.

Then, gybing fiercely in a squall, the hook came off the gaff and the sail was pulled against the mast with only the signal halyards to hold it. George towed to the mooring, expecting the sail to come down at any moment. It was a sad end to an exhilarating sail across the broad.

Once they were safely moored, John Young went aboard and with his help they managed to correct 'the pulleys'. This done, they joined the Youngs for an enormous 'end of the holiday' tea. By contrast, supper was a makeshift affair, as George put all their remaining provisions into a hotpot which they shared with the Arnold-Fosters. After washing up the boys tumbled into bed, tired out although it was only 9.30 p.m. They spent the night 'between some hymn-singing girls to starboard and yelling schoolboys to port'.

The Ransomes were up and away while the rest were cooking their breakfast. Abandoning their cooked breakfast, the boys set sail, munching cake as they did so. They stuck fast in the south entrance to the broad but the schoolboys saw their plight and came to the rescue. They tacked across Wroxham Broad and after some difficulty found the north entrance. Once in the river they tacked and quanted through the bungalows to the boatyard where they were nearly rammed by some 'hullabaloos' towed by a motor launch. There was a frantic rush to lower the sails and pole the *Fairway* to the mooring, wash down and tidy up ready for the Ransomes' inspection.

'So ended a marvellous cruise', George concluded, but added a note that Raymond had developed 'the plague' later that day, and so all the youngsters were now in quarantine!

By the time of the 1939 cruise the Altounyans had returned to Syria, but two young girls, Vicky and Susan Reynolds, aged ten and eight, and their parents joined the party. This time there was a 'perfect fleet' of identical *Fairways*. Josephine's mother had finally relented and she was allowed to join George and Christopher, a friend from school.

The cruise started on Saturday 15 April. George noted that the crew of *Fairway X* arrived in Wroxham by train before midday, but they had to wait around for the Ransomes to leave before they were able to take their boat out of the yard. This year they were hardened mariners and there was no trial trip with a boatman. The wind was strong and gusty, and when eventually they were able to leave after 5 o'clock with Josephine appointed first mate and Christopher as second, it was under double-reefed main and jib.

All went well until the wind headed them close to the entrance to the broad and they rammed the bank twice in quick succession. The second time they had difficulty in breaking free of the tree that had caught in the rigging, and when they finally did so, they took some of it with them, caught in the gaff. They reached their usual mooring without further mishap and, having lowered the mainsail, they were just taking breath and saying 'Here we are!', when a roar from Ransome ordered them to lower the jib, 'immediately'!

Once stowed to Ransome's satisfaction, they set about preparing their first supper aboard. They feasted on tomato soup, chicken sandwiches and fruit, and followed up with bread and jam.

A 90 mph Gale at Thurne Dyke
Vicky and Susan Reynolds with Arthur Ransome battling against the wind. (Courtesy Josephine Russell)

George does not say exactly what it was, but there was some horseplay with the Youngs that first evening, before they were able to settle down for the night.

They awoke around seven and George brewed a pot of tea for his crew. This was quickly followed by breakfast and a consultation with Ransome, who told them that the meeting-up place for the night was the mouth of Thurne Dyke.

The wind was south-westerly, still strong and quite blustery, and Ransome advised a double reef. They sailed down to Horning without trouble, but in coming up to the bank opposite the staithe they hit much harder than intended. Fortunately the bank was soft just there and Christopher on the foredeck managed to keep his footing. By the time they had moored and stowed their sails and helped the Reynolds to moor, it had begun to rain. The boys headed for the shops but Josephine remained behind, struggling in vain to get the toothpaste back into the tube that she had trodden on. They bought papers and some beer from the Swan. While they were having what George called a 'scrappy' lunch, the Ransomes sailed past without bothering to stop.

With a good south-westerly wind, they had an easy reach to Ant Mouth and on to Fleet Dyke, hoping to reach South Walsham. In the narrows they came across a moored wherry. They could not sail past the wherry against the wind so they decided to tow through the gap. The worthy attempt ended in failure for George, who was towing and found the wind too much for him and was 'nearly cut in two for my pains', and Josephine in the well was unable to see him.

They managed to turn the *Fairway* and return to the mouth of the dyke where they were struck by a squall. Fearing to risk a gybe to go down the Bure, George wisely 'wore ship' (turning away from the wind to change tack). He did so again as they made their way to Thurne Mouth, passing the Youngs on the way as they stopped to take in a second reef. They were frequently being driven onto the lee bank and it was a very relieved skipper who eventually was able to head the *Fairway* up the Thurne.

They quickly lowered the jib, scandalised the main, warped into the Thurne Dyke and moored alongside *The Commodore*. Once stowed, they returned to the mouth so as to be on hand to help the Youngs and Reynolds.

They had supper that night as guests of the Reynolds at The Lion Inn and so were rather late to bed after such an eventful day. It did not matter, as it happened, for the wind had increased to gale force and was sweeping across the flat country around the Thurne, making it quite impossible to attempt to leave their moorings. They gave the boats a thorough cleaning and made the best of the day. They played games – 'shipwreck' and 'boat race', lots of darts at The Lion – and they walked to Potter Heigham. George recorded that gusts had reached 90 miles per hour so that at times walking was quite difficult. In the evening there was food at The Lion, beer and more darts and they listened to the wireless in the bar. By the time they returned to the *Fairways* it was raining and turning into a thoroughly cold and unpleasant night.

Next morning it was dry again but the wind had not abated and so they put off sailing until after lunch. Meanwhile there was more cleaning up and more darts.

It was arranged that the fleet would meet at Ludham Bridge, 4½ miles away, as the wind had swung around to the north and seemed to be dropping. The short reach to Thurne Mouth was uneventful but once in the Bure they begun to live up to their flags. Coming across a number of yachts heading in the same direction, George reported that they, together with the Youngs, had 'dealt with' them so successfully that their adversaries had tied up at the side until they had gone on. They were rammed in their turn but Josephine pushed the offending boat off so forcefully that they went into the bank.

This raises the question of whether Ransome was aware at all of the more extreme 'piratical' larks that might so easily be described as the antics of hullabaloos? Both Taqui and Josephine went on record saying that he was a stickler for sailing correctly. Even trailing a hand in the water would cause comment! Similarly, the *Fairways* had to be kept scrupulously clean and tidy, and when Taqui once left a banana skin on deck she was never allowed to forget it.

They had tea with the Ransomes near the mouth of the Ant and watched the Reynolds shaking out a reef 2 miles away. Eventually the fleet lowered masts and all were towed up to Ludham Bridge. Ransome decided to press on and pass through the bridge so that they could moor where they could take on board a supply of fresh water.

George cheerfully recorded that Josephine made a mess of their supper and then went and raced and lost!

There was very little wind the next day, with what there was coming from the north-west. Nevertheless Ransome ordered the fleet to make for Barton Broad. Remembering how they were burnt by the sun on a similar day of bright sunshine the previous year, they tried unsuccessfully to buy white hats at the Bridge Stores before setting off. By a mixture of towing in the dinghy and quanting they were able to get away and after about 1½ miles of this effort they found that they were able to sail.

At Irstead they passed the Reynolds, who had stopped for lunch and so that the girls could have a bathe in the shoals. George decided they too could have a brief stop while they had something to eat. More hard work brought them through the narrows and

Meadow Dyke
In the narrow, winding dyke there is little room to tack and quanting is often the order of the

they were the first to enter Barton Broad, leaving the Youngs anchored at the southern end.

There was more wind on the broad and they decided to make for Stalham. This time George was careful to keep to the channel. They crossed the broad and reached the long dyke leading to Stalham Staithe but had to abandon the attempt when the wind failed them and they had to quant back to the broad.

Meanwhile, the Ransomes had dropped their mudweight in the broad, and when *Fairway X* arrived back, the crew were plied with bottles of grog. Refreshed, they crossed the broad. They had 'a little difficulty' at Irstead but afterwards they had 'a running fight' with the Youngs. They dropped Josephine at the mill a mile or so above the bridge and she continued in the dinghy. The boys carried on and shot the bridge without Josephine, and George remarked how efficient Christopher had become. There is no mention of Josephine rejoining the *Fairway X*. Clearly there had been some trouble, for George was in the habit of putting down his younger sister.

The return to the mooring was the easiest sailing of the day. Once stowed, the Primus came out and there was a 'colossal' supper of asparagus soup, stew, plum pudding, fruit and beer. After supper they all turned out to watch the eclipse of the Sun. It had been a very laborious day in which they had towed, quanted and sailed 10½ miles. George rated it 'perfect', only marred by lack of wind.

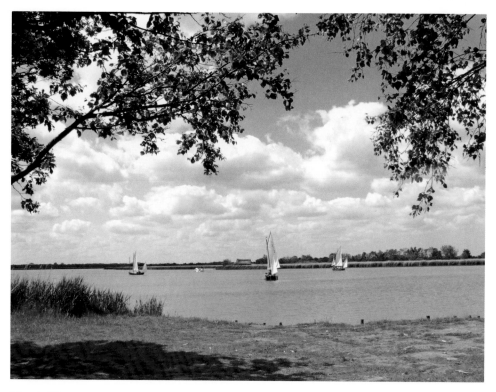

Horsey Mere
A party of youngsters learning to sail seen from the mouth of the dyke leading to the windmill.

Next day there was a light westerly wind and Ransome decided to try for Hickling. The crew of *Fairway X* were rather late waking, but hurried things along and soon had their breakfast and prepared sandwiches and boiled eggs to eat while underway. At 9.40 a.m. they were ready and cast off just behind the Ransomes. Leaving the two mates in charge, George tidied the foredeck, hoisted the jib, washed down the decks and cleaned his teeth! They were able to run down the Bure and sail close-hauled for most of the way up to Potter Heigham, where they moored by Herbert Woods boatyard to lower the mast.

Once through the bridge they stopped to raise the mast and while the boys went to the post office in the village half a mile away in search of letters, Josephine went shopping by the bridge and bought the white sun hats that they had been wanting.

By the time they set off for Kendal Dyke, still eating ice-cream, they were at the tail of the fleet. They passed the Youngs in Kendal Dyke and met the Reynolds as they tacked across Whiteslea, having stopped for lunch and so that they could dry Vicky's clothes! Continuing to Hickling they came across a noisy outboard motorboat that they raced across the broad.

At the Pleasure Boat Inn they met the Ransomes to find that Evgenia had been hit in the eye by the rond anchor. They 'bought up the shop' before having a very pleasant sail across Hickling and down Kendal Dyke. Once in the Thurne they had to tack, overtaking

the Youngs with whom they 'exchanged a broadside', then passed successfully through the bridge once more. The Reynolds treated them to a 'colossal' late tea ashore. They began the long quant down the Thurne cheered by the sight of Thomas Young falling in! Finding they could 'ghost' the last mile under sail, they arrived at Thurne Dyke to discover it so full that they had to anchor outside, where there was an unpleasant smell of mud.

After a hasty supper they went to bed having covered 16 miles since they left the mouth of the Ant twelve hours earlier.

Everyone was astir early for their last day and hurrying to be away. There was a decent north-westerly wind and as soon as the Youngs were ready, they began the gentle run down to Thurne Mouth. A close reach and a single tack took them to Ant Mouth and their old mooring at Horning Hall. After that flying start, progress was slower because of the trees. Meanwhile, Ransome had moored near to Horning Ferry where he could signal to the others to tell everyone to stop at Horning. The staithe was crowded so they moored on the opposite side of the river. Then when they had helped everybody in the mates went shopping.

After lunch the Youngs were away first but there was great glee aboard when they went aground and *Fairway X* overtook them. George noted that before Wroxham Broad they had passed a *Fairway* and three *Whippets* and were the first to enter. The two mates took over and sailed to and fro across the broad waiting for the rest of the fleet. At last they saw the Ransomes and the Youngs at the south entrance, so they turned to meet them and took photographs, and all together went on up the river.

The cruise ended with a celebratory water fight, or as George called it, 'a bloody battle'. *Fairway X* lay alongside the Young's *Fairway* and they hurled water at one another using their mops. At last they managed to capture the Young's mop and hauled it to their masthead. Once peace had been restored, they quanted up to the yard and had their tea-supper. After they had washed up, the boys went to play darts with the Ransomes in the pub while Josephine remained aboard. It being Friday night, the pub was very full, and soon everyone was crowding into one cabin for a final talk while the Ransomes handed round a box of Black Magic chocolates.

The following morning everyone was up soon after 7 a.m. and after they had had an early breakfast and washed up, they completed their packing and set about washing out the cabin, cooking lockers, food lockers and the well, and then with a glow of satisfaction called in the Ransomes to inspect.

George ended his log with an appraisal of the week:

So ended yet another pleasant week. Two very squally days and four perfect ones. We could not possibly grumble. Everything went like clockwork. The crew was almost unbelievably efficient when kept up to the mark. They even impressed the Ransomes. The standard of washing was high considering the average of the whole fleet, while as pirates we could take on the best, even trouncing the battle-scarred *Falcon*. I am sure Araminta and her colleagues will long remember the second mate's Herculean heave, while the first mate was an admirable curator of the cockpit, in spite of occasional howls of, 'Which way are we going?'!

LONG LIVE THE NORTHERN RIVER PIRATES

Total mileage 55 in four and a half sailing days

Coots in Trouble
The Big Six

Once *Coot Club* was published, Ransome had begun a new book about the Swallows and Amazons hunting for gold, but with the business of moving and with a sea-going yacht to sail, this had to be put aside and there was no new Ransome for Cape to announce that Christmas.

Nancy Blackett's frustration at her surrogate father Captain Flint's frequent absences during their school holidays provides the starting point for *Pigeon Post*. When the book opens he has been off prospecting for gold in South America. Having got hold of some yarn of gold in the Lake District fells, Nancy sets the Swallows and Ds searching, in the belief that if they are successful her Uncle Jim will not be miles away when she wants him to join in her games. There is a hated rival prospector to outwit and some real-life danger before they end up fighting a fell fire and discover that their 'gold' is not gold at all but copper. *Pigeon Post* won the prestigious Carnegie Medal for the best children's book of 1936 but Ransome was almost too busy sailing to go to receive it!

His next book featured the *Nancy Blackett* (renamed *Goblin*). The Swallows have come to Pin Mill to meet their father who is returning to England to take up a shore appointment. While they are waiting, they go sailing in the harbour with a young man they have just met, and when he goes ashore for petrol and fails to return, they find themselves drifting out to sea in a fog.

We Didn't Mean to Go to Sea contains some of Ransome's best writing, but he was a little unsure of its reception. 'I fear a lot of people will think the thing's too tough for babes', he told his publisher.

Having completed the book in time for Christmas 1937, the Ransomes went off to repeat their fishing holiday on the Broads. In the middle of October they had hired a small cruiser, but Jack Powles let them have the *Royal Star* with two cabins so that they would be more comfortable.

They were able to make a leisurely start from home and still be in Wroxham by 2.15 p.m. Leaving the yard in the late afternoon they stopped at Horning to stock up with new pike tackle and also bought a 'froggy' teapot that caught their eye. They passed the black sheep by the vicarage just as it was getting dark but they kept on until they reached the mooring at Horning Hall once more.

They were up early on Sunday morning and fished for three hours, by which time they had bream, small roach and a dace swimming in the keep nets. After this good start to the day they decided to make for a mooring up the Thurne, where they were

due to meet a fisherman friend and his wife for lunch. Back on their own boat later that day, the rods came out again and they fished until dusk. Scores: Arthur sixteen, Evgenia fourteen; 'but E had all the best fish'.

They woke to find that it was a 'gorgeous' morning and soon shifted to Thurne Mouth to begin fishing. Four hours later they made their way up to Potter Heigham where they had lunch and chatted with Walter Woods at the boatyard. Motoring upstream from Potter Heigham later that day, they stopped to buy milk at the farm below Kendal Dyke and fished again until it was too dark to see their floats.

'Scores, roach and dace: Arthur fifteen, Genia seven. Bream: Arthur two, Genia six. (Two of Genia's roach v.g, mine all smaller).'

The next morning was entirely devoted to fishing, and between them they caught fifteen roach, some of which were over 1½ pounds. Trying to move on during the afternoon, they found that the engine would not start. Ransome was notoriously bad with engines, but there is no mention of whether they managed to restart it or if somebody from the boatyard was summoned.

The following morning they fished in Kendal Dyke but caught nothing large and in the afternoon motored to Potter Heigham so that they could call on the wife of their friend that they had visited on Sunday.

The next day they invited their friend aboard the *Royal Star* but the day was ruined for them because the good lady would chatter on, oblivious to the fact that fishing was a serious business requiring concentration, and there was great relief aboard when she decided to go home to do some gardening. Their catch was a disappointing one and Ransome was considerably put out.

The following day was cold and windy when they motored up the Thurne to Martham Ferry, close to the place where the Death and Glories would catch great pike in *The Big Six*. They each caught a good roach and a string of little ones and Ransome caught a rudd.

There are no more diary or logbook entries other than a note that they returned the *Royal Star* to Wroxham on Monday 24 October. However a surviving letter written aboard explains why they stayed where they were to keep warm.

> Actually the boat is quite snug and until those beastly gales started we were catching lots of fish, a pound perch, a roach well over one and a half pound, rudd, and lots of bream. Genia refuses to consider going home, so here we stick, and at the moment listen to a raging hurricane overhead, and the groan and sigh of a windmill, or rather windpump, which is whirling like a dervish at the head of the reach.
>
> The Broads are absolutely deserted except for strong fishermen. We haven't seen one boat today except a wherry and a reedboat.

A month later Ransome was back in Norfolk again. Shortly before the fishing holiday he had strained himself trying to free a rope aboard *Nancy Blackett*, and because he still suffered from various internal pains from time to time, it was several weeks before he consulted Dr Blaxland in Norwich. Blaxland diagnosed an umbilical hernia and on 24 November he operated. When complications set in, the story goes that Blaxland

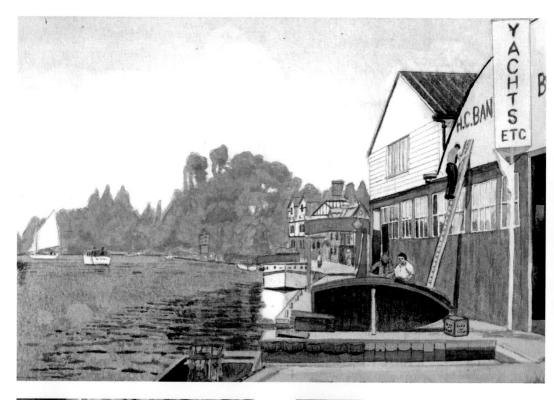

Above: Bygone Horning
– Banham's Boatshed

Left: Bygone Horning
– the Village Pump
The well-known pump
on the green, with the
newsagents and thatched-
roof post office in the road
beyond it.

rushed to the rescue in his dressing gown, and Ransome was eternally grateful to the 'large-hearted' surgeon who had saved his life.

Convalescing in the Norwich nursing home allowed Ransome to plan the new boat that they were intending to have built to replace *Nancy Blackett*, for Evgenia insisted that the cabin, and particularly her galley, was too cramped for the sort of meal aboard that she enjoyed preparing. His friends plied him with detective stories and Margaret Renold, who knew of Ransome's pleasure in reading Agatha Christie, suggested that he try his hand at a detective story himself and he admitted to her that he rather liked the idea.

By that time he had fallen under the spell of the secluded and ever-changing wilderness world of marshes, creeks and islands known as the Walton Backwaters, where they had spent peaceful days anchored in *Nancy Blackett* and he thought that something might be done with that in a sequel to *We Didn't Mean to Go to Sea*.

When he appealed to Margaret Renold to come up with a suitable crime for his detective story in January 1938 he told her that he thought George Owdon would make a splendid villain and Tom and the Death and Glories with the help of the Ds could be the detectives. He had seen at once that the motive for the detection must be more than merely a desire to see justice done. It required the urgency that only a desperate need to clear themselves of some crime would provide. He was very explicit about the time of the year: it must take place in November or December or the Christmas holidays in order that he could have some fun with the stove in the cabin that the Death and Glories have built on their old boat during the summer holidays following *Coot Club*. There would be a 'ghastly' episode when they try to smoke eels and a fine one when they feast on a methylated spirit-soaked Christmas pudding. He also had in mind an episode with a fisherman, a monster pike, the Death and Glories and an innkeeper. Furthermore, he explained, whatever the crime might be, it must be one that could be repeated, so that in the end the detectives could catch the villain in the act. Finally, he told Margaret Renold that the crime must have nothing to do with boats!

The Death and Glories were not the first young boatbuilders on the Broads, for Frank, Jimmy and Dick had built an odd little craft more than fifty years earlier on which they spent a three-week holiday, in George Christopher Davies' *The Swan and her Crew*. At the time Ransome was planning *Coot Club*, Margaret Renold had suggested a Loch Ness Monster hunt on the Broads, during which the Coots find a poacher's bundle. Ransome dismissed the idea as being 'too much like *The Swan*', which shows that he was familiar with the book.

Margaret Renold was unable to come up with a suitable crime for George Owdon to commit, which is hardly surprising, since village life in Horning (then and now) centres around the river. Nevertheless in February 1938 Ransome wrote two episodes that would find their way into *The Big Six*. He completed an account of a night spent with one of the few remaining marshmen at the eel sett that he had mentioned in the notes for *Coot Club*. The days spent fishing in the upper reaches of the Thurne provided the impetus for the classic tale of the capture of a monster pike.

In March Ransome floated the detective story idea to his publisher, but he also mentioned his vague idea of a Mastodon Boy who lived on the shore of the Walton

Malthouse Broad
The yacht's crew have dropped their mudweight and piled into their dinghy in order to visit the crowded staithe at Ranworth.

Backwaters and watched some newcomers being chased. Wren Howard of Cape replied that he much preferred the Mastodon Boy story and Ransome agreed, while remaining optimistic that there was a good detective tale to be told, if he could only fix upon a suitable crime.

The Mastodon Boy might have secured Cape's vote, but soon Ransome had serious doubts, and he told Helen Ferris he had come to the conclusion that he 'didn't really like it' but that his other 'much better notion' was only a glimmer, so that he was afraid there would be no new Ransome in the shops for Christmas 1938.

That spring and summer he produced a long draft for a new book, but it had nothing to do with the Mastodon Boy or George Owdon, for he had haunted the Pin Mill boatyard and recorded every detail of the new yacht's construction, fitting out and launch, in anticipation that one day he would write another cruise book. The Second World War put an end to that ambition, and the Ransomes had only the closing stages of the 1938 season and the uncertain summer of 1939 to enjoy *Selina King*, the vessel that seemed to suit their needs perfectly.

Ransome did not begin work on *Secret Water* until after his last trip in *Selina King* in December 1938. Whenever he was not sailing, he continued wrestling with the book until the following September. *Secret Water* is one of his most original plots yet in some

ways an unsatisfactory one. The Swallows are marooned on an island in the Walton
Backwaters with the intention of exploring in their dinghy and mapping the creeks
and saltings. They are befriended by the Mastodon Boy, who enters into an alliance of
blood brotherhood that he regrets almost as soon as it has been concluded when the
rest of his savage tribe tell him to chase off the strangers from their private territory. To
complicate things further, Nancy and Peggy arrive almost as outsiders, and they find
the prospect of a war with the savages much more attractive than mere map-making,
The introduction of Bridget, old enough at last to join her siblings, adds interest and
humour. It is her capture by the savages that provides the means of bringing peace
between the tribe and the invaders.

Cape liked the book and printed 10,000 copies, followed almost immediately
afterwards by a further 5,000. While foreseeing possible distribution problems, the
publishers did not think that the impending war would lesson the demand for books
for children, but they urged Ransome to steer clear of the subject of war at all costs.

Work began on *The Big Six* on New Year's Day 1940. By this time the Ransomes
had moved across the river to Harkstead Hall, so as to be closer to Pin Mill. It has been
said that Ransome stayed at White Gates in Horning while he was writing *The Big Six*,
but this is not so. He probably stayed there in September 1945 when visiting *Selina
King*, which had been laid up at Oulton for the duration.

Ransome had kept the forty-two pages that he had written two years earlier and
called 'Night Affair', 'The Big Fish' and 'The Roaring Donkey'. It is interesting to find
that 'Night Affair' was written from the point of view of Tom Dudgeon:

> A pair of seaboots were at the side of the bed. A packet of sandwiches was on the table.
> Across the lower part of the window was a crowbar, held at each end by a block of wood,
> screwed to the window frame. A coil of rope lay on the floor. A thin line of string led from
> the window, which at the bottom was just open. It led from the foot of his bed and in
> between the sheets … A rattle of small gravel sounded against the window. Tom freed his
> foot from the string, went to the window and looked out. In the moonlight on the path
> below someone was crouching on hands and knees.

The Big Six gains immeasurably by being written from the viewpoint of the three
small working-class boys of the *Death and Glory*, mystified by the village's immediate
assumption of their guilt and resentful of the way that they are avoided after boats
have been cast off, but secure in the knowledge that their parents, Mrs Barrable and
Mrs Dudgeon believe them innocent.

Eventually, Ransome had decided that there was no alternative to George Owdon's
criminal activities involving casting off boats.

The Death and Glories have spent their summer holidays building a cabin on their
old boat so that they can sleep aboard at night and they have fitted a stove to keep
them warm in winter. They are looking forward to being able to watch over the nesting
birds at all hours the following spring. It had been established in *Coot Club* that
George Owdon stole the eggs of rare birds and sold them to a man in Norwich. He
was going to find it difficult to continue pillaging nests without interference, but if

the Death and Glories were to be stopped off the river... When there is an outbreak of boats being loosed from their moorings, there is anger in the village and there are calls for the villain to be caught. Ransome had found the motive and the perfect crime. In the spring of 2012 it actually happened when a boatload of visitors were cast off from their Yarmouth mooring. When appealing for witnesses, the police described the crime as 'completely irresponsible' and potentially endangering lives. Tom Dudgeon's affair with the cruiser is common knowledge, so Mr Tedder, the local policeman, looks no further than the Death and Glories, newly freed from parental control by the completion of their cabin.

During the night that they spend with the eelman, more boats are sent adrift, and after the *Death and Glory* has been towed above Potter Heigham bridges, where they catch the huge pike, they find that casting adrift has occurred while they were there, and what is worse, a lot of shackles have been stolen from the Potter Heigham boatyard.

Only with the arrival of Dick and Dorothea do the Coots begin to think that somebody is doing it on purpose. *Sir Garnet* is set adrift during the night that she is moored alongside the *Death and Glory* at Horning Staithe, and when the Death and Glories go to Ranworth to escape the wrath of the villagers, boats are cast off there as well. Dorothea suspects that somebody else is pushing off boats while the Death and Glories are there to take the blame. 'What we want are detectives', she announces, and Tom and the Ds find clues at Ranworth leading them to believe the criminal is a Horning person and has a bicycle with Dunlop tyres.

The Coot Club Shed beside Tom's house becomes 'Scotland Yard' and the next day Tom and the Death and Glories cycle to the various riverside villages to see if other boats have been cast adrift. Their detective work yields nothing, but that evening Dorothea spots somebody patting the chimney of the *Death and Glory*, which they have hidden in the wilderness, just along the river from Tom's home. William the pug chases after the intruder and returns with a scrap of grey flannel from his trousers.

The next morning the Death and Glories find that a few of the stolen shackles had been stuffed down their chimney. They take them to Mr Tedder, the policeman, who is already convinced of their guilt and who believes the shackles will prove it. The detectives set about examining all the Horning bicycles and listing all those with Dunlop tyres. Dorothea is convinced that the villain will return with the rest of the shackles and Dick comes up with the notion of painting the chimney to capture a fingerprint when he does.

Nothing happens the first night because Mr Tedder is hanging around in the hope of searching the *Death and Glory*, but late the following evening they find a perfect print on their chimney and more shackles aboard. Mr Tedder wants to summon the Death and Glories but Dr Dudgeon, who is a magistrate, tells him to hold off until the detectives have consulted a solicitor. Conveniently, Mr Farland, the twins' father, is a solicitor and he agrees to see them the next morning.

Going through their evidence, the detectives realise that in spite of all their clues they have still not identified the villain and so proved that the Coots were innocent, though Dorothea reasons that it must be George Owdon. When the fisherman friend who had towed them to Potter Heigham stops by the *Death and Glory* to ask about

Horning Reach
By careful selection it is still possible to capture the scene much as it was in the 1930s. An unusual balanced lug-sail day boat and wooden cruiser add to the illusion.

moorings, they take him into their confidence and he agrees to moor his cruiser below the ferry so that the detectives can attempt to catch the villain in the act of casting her off. The complicated plan works, but until the photograph that Pete has taken has been processed and shown to Mr Farland, it seems as if all their evidence has actually proved nothing.

The densely woven plot gave less trouble than any book since *Swallows and Amazons* and Ransome felt free to write whichever episode seemed easiest or most attractive at the time. He began with the opening, which he called 'Quayside Scenes' and followed with a revision of the eelman chapter (Chapter 3) and the Death and Glories' return to the staithe towing the yacht found with her mast in the trees (4). Ransome then wrote the chapter describing the setting up of Scotland Yard in Tom's shed (15). After this he wrote the very end of the book when the great pike in its glass case is carried to the Roaring Donkey inn.

Next Ransome turned his attention to the actual flash-light trap, the blinding flash and afterwards in the *Death and Glory* (26, 28 and 29). These scenes were followed by the early episode of the smoked eels (5) and then a long run of chapters in sequence after the Death and Glories return from Potter Heigham and stock up at Roy's stores with the money that they have earned catching the pike. The party aboard to welcome the Ds was followed by the escape to Ranworth, the discovery of the first clue and the unwanted gift of the first lot of shackles (9–14).

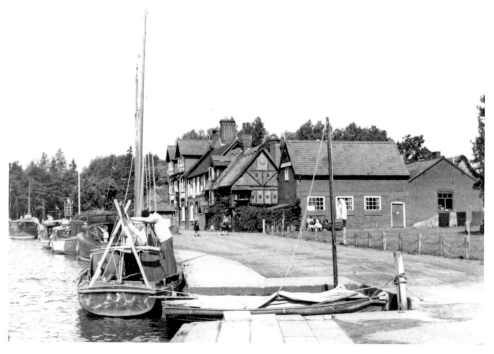

Horning Staithe
This 1950s view shows the staithe much as it was twenty years earlier. Today, with its curb stones, 'no parking' notices, allotted parking spaces and electric hook-ups it has lost much of its appeal.

Ransome then rewrote the scene with the fisherman, 'A Kid for the Tiger' (26), followed by the sequence, writing from the first chimney painting, 'Morning Visitors', the second coat of paint, 'The Villain Leaves His Mark', 'Things Look Black' and 'The Last Chance' to the opening of 'A Kid for the Tiger' (20–25).

A late chapter, 'All the Evidence We Got' (30) came next, and then Ransome wrote the early escape from Horning to Potter Heigham, 'Tow out of Trouble' (6). Last of all he seems to have thought of putting the Coots in the various waterside villages on the alert and finding out if boats have been cast off in other places, and wrote 'Spreading the Net' (16).

This was the stage that he had reached at the end of April with 401 pages of draft. At this point he does not appear to have tackled Chapter 2, 'First Sign of Trouble', Chapter 17, 'News From the Outposts', Chapter 31, 'In the Darkroom' and the climax, Chapter 32, 'The Legal Mind'.

There is every reason to believe that Ransome enjoyed writing *The Big Six*. On 6 May he wrote in his diary, not the usual lament, but 'Framework better than WD' and a week later he began the second typescript. Ransome had every reason to feel confident, for the comments made by Evgenia when she had read the first draft – that the framework was the best yet, two of the chapters were good and that she had laughed several times – amounted to fulsome praise.

The Wilderness Dyke
The dyke leading across what was once the 'Wilderness' has been widened and smartened up, but is there still a sense of mystery at the far end near the road?

He was in a light-hearted mood when he wrote to Wren Howard later that month, 'I beg to report that I have started full tilt at the revision of "Hot Water", "Not Us", "Coots in Trouble", "Who the Mischief", or God know what.'

A little later, as the Battle of Britain began to take place overhead, Ransome went so far as to admit in a letter to a sailing friend that he was getting some fun out of writing it in spite of the difficulty of concentration. The word fun also appeared in a letter to his mother written at about the same time: 'If I can only bring it off right, it will be great fun and quite different from the others.'

The only note of discord arose over the title. In July Ransome appealed to his mother and his supportive Aunt Helen to help settle the 'battle royal' that was taking place between Wren Howard and himself. Howard wanted to call the book *The Death and Glories*, while he much preferred *The Big Six*. In the event their combined verdict was not particularly helpful. His mother agreed that *The Death and Glories* sounded too warlike, but Aunt Helen preferred that title. In the end Ransome had his way, but with the benefit of many years of peace, perhaps Wren Howard was right, as *The Big Six*, even in 1940, was sufficiently obscure to require an explanatory note on the title page.

There would be no last-minute rush or panic with *The Big Six*. Cape had the typescript before the end of July!

Ransome settled down to draw the pictures, and during August he allowed himself the luxury of some fishing, and yet he still managed to send off the pictures at the beginning of September. As soon as Cape received the drawings they were despatched to the block maker. The day after the blocks had been completed, the block maker's works was bombed and the whole building was demolished. Fortunately, most of the original drawings were safely back with Cape.

London was facing the worst of the Blitz, Wren Howard was fire-watching at night, Cape's premises lost some windows and the staff were working in the basement, but even so, Wren Howard was determined that somehow or another *The Big Six* would be ready in time for Christmas. Ransome had to do a certain amount of redrawing and rather than draw a fresh endpaper map, he carefully added Coltishall, Irstead and Barton Turf to the 'Northern Broads' map from *Coot Club*.

The Big Six was published in late November and Cape were sufficiently impressed to use up what had become a precious supply of paper for 12,000 copies. The book has not been without its critics, many of whom have misunderstood it, complaining that the identity of the villain is obvious early in the book. Throughout the twelve novels, as Ransome explained to his publisher, he was writing for a young audience whom he expected to read with intelligence. He knew that they would suspect or grasp, almost from the first sign of trouble, that George Owdon was the villain. The book is an account of detection, of the Coot Club's efforts to clear their name. Knowing the identity of the villain does not diminish the tension or the satisfaction of a happy conclusion. Above all it is an optimistic book written at the lowest period in the country's history. The Coots' struggle to prove their innocence could be seen as a metaphor for Britain standing alone against the might of the Third Reich.

Less obviously than its predecessor, *The Big Six* is a record of the Broads scene between the wars but Ransome's response to landscape is as compelling as ever. When the Death and Glories are towed away from trouble and, with knives in their teeth, scout through the mist in search of the *Cachalot*, Ransome presents a memorable image of the river in a few words: 'The morning mist was heavy on the river and the sodden fields that lay on either side of it...' When I first visited the village of Horning in the 1950s, it felt almost as if I were returning to a place that I knew well. I suspect that many have been drawn to Horning village, as I was, after reading the first page of *The Big Six*: 'The staithe? Everyone knows the staithe...' The opening also serves to show how good has been the life of the three small boys, before they become suspected of the vandalism and theft that casts a shadow over the remainder of the book. Only in the last line of the book is there a return to carefree days with Tom's joyful, 'Come on. Let's all go sailing.'

The interest shown in the several websites and books that publish old postcards and memories of the Broads suggests that many people have a feeling of nostalgia for the Broads of forty or more years ago. Readers of *Coot Club* and *The Big Six* have the benefit of Ransome's scene-setting that is economic yet so appealing, such as the closely observed description of the eelman's houseboat, with its Jack Tar stove, patchwork bedspread, ancient gun and fishing tackle, which offers a glimpse of a disappearing way of life where the old marshman 'lived and mended his nets and watched the river'.

Swan Inn
These days the Swan Inn has extended to include the seventeenth-century thatched cottage next door, but this view is much as Arthur Ransome knew it, including the notice board referred to in both *Coot Club* and *The Big Six*.

A century ago there were any number of eel setts around the Broads. The most likely candidate for the original of Harry Bangate was Tom Cable, whose sett was in Kendal Dyke. Cable said that he made a point of fishing when the moon was on the wane and he found that wet and windy nights were the best conditions. If the keep was raised during the day a red light gave warning. Raised during the ebb, the net remained in place for five hours or so until the first of the flood had washed out the rubbish, after which it was lowered once more. Today the sett is the last surviving working sett in the country and the Broads Society arrange demonstrations in the autumn.

There is a mention in the book of the stuffed pike in the Swan Inn. In the 1950s the Swan Inn had a famous collection of stuffed pike. By the 1980s there was only one, the fine pike caught by a young Horning lad that is now on display in the Museum of the Broads and possibly the inspiration for the 'World's Whopper' episode. The restaurant trade is so important these days that the pike was removed from its place of honour over the bar because it was feared that it might put diners off their meal. There is still plenty of sport to be had trying to catch a monster pike, but photographs recording the triumph have replaced the work of the taxidermist.

By the time that he was writing about adventures on the Broads, Ransome was well aware of the scrutiny that his readership applied to his Swallows and Amazons books.

The *Death and Glory*
Arthur Ransome carefully planned the addition of a cabin to the old ship's boat in this sketch.

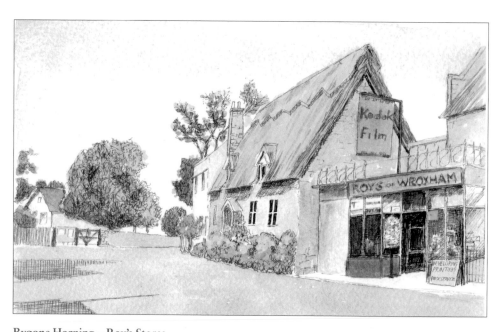

Bygone Horning – Roy's Stores
Roy's Stores where the Death and Glories shopped when they had any money stood across the road from the Swan and was built in the garden of a thatched cottage.

Ransome enthusiasts have searched Norfolk in vain for the Roaring Donkey inn, although there is a suitable dyke near Martham that has been much enlarged in recent years. There was, however. a 'Barking Dickey' (Norfolk for singing donkey) to be found in Westlegate, Norwich. Originally the nineteenth-century pub was known as the 'Light Dragoon' but the badly painted sign looked like a braying donkey. Apparently the inn was no more successful than the Roaring Donkey and it is now a café.

Ransome realised that it would not do to have the Dudgeon family and the Farlands living in identifiable houses along Horning Lower Street. Nevertheless, the illustration in *Coot Club* shows that Tom lived in a sensible thatched-roof house somewhere beyond the last big boatshed, only a short lawn away from the river, and a sketch for *The Big Six* reveals that Mr Farland's house was built in the Tudoresque style that was appearing along the river at the time.

The wilderness has suffered from the attention of developers until it is unrecognisable as the osier-covered marshy sanctuary where the *Death and Glory* lay hidden in *The Big Six*.

A large-scale map of the time shows that Ransome took a few small liberties: the dyke leading to the meadow where the kid lay in wait for the tiger was actually a broad dyke which led to the boatyard where Ernest Woods established his business in 1927.

Readers who knew the village of Horning before the demolition of the Banham's boatyard in the late 1960s would recognise his yard masquerading under the name Jonnatt's. Curiously, although the homes of Tom Dudgeon and the twins have defied precise identification, the location of Pete's home was described and, until the area was modernised, was readily found. Similarly, a likely cottage by the staithe for Mr Tedder has disappeared in the rash of new development that has overtaken the village along Lower Street.

As Jonathan Cape foresaw, *The Big Six* proved so popular that it was reprinted every year until 1946. Shortly after publication the Ransomes moved back to the Lake District and the shore of Coniston Water. Here he wrote *Missee Lee*, a sequel to *Peter Duck*, but much more original and inspired by the visit that he had made to China in his journalist days. Captain Flint and his crew of Swallows and Amazons are taking the *Wild Cat* on a circumnavigation of the globe, but when they are off the pirate-infested coast of China the schooner is lost by fire and they all end up as prisoners of a mysterious pirate chief called Missee Lee. She turns out to be a Latin scholar running a protection racket and head of the Three Island pirates. How they all manage to escape with Missee Lee's covert help makes for an enthralling romance.

Two years later *The Picts and the Martyrs* appeared. By contrast it is a quiet tale of the Ds living in secret at Beckfoot for ten days while the formidable Great Aunt (from 'Swallowdale') is staying there. Evgenia hated it, but the return to the lake country after four books away was warmly welcomed, and the book sold very well. Many adult readers rate it among their favourites. Like *Coot Club*, *The Big Six* and *We Didn't Mean to Go to Sea*, in *The Picts and the Martyrs* the children are not playing games but engaged in the serious business of keeping the Ds' presence secret in the face of increasing complications for the sake of Mrs Blackett, who is away recuperating on holiday.

Epilogue

The One That Got Away
The Death and Glories

Ransome turned his attention to the affairs of the Coot Club for the last time in May 1943, shortly before *The Picts and the Martyrs* was published. Taking his cue from a letter mentioned in the book that explains that Professor Callum was known to be marking up a catalogue of Broads craft for hire, Ransome wrote a fragment starting with a letter from Mrs Barrable to her old pupil Mrs Callum, warning her not to come to Horning in August as the whole place was 'a seething cauldron of hullabaloos'.

Mrs Callum replied saying that they were planning to go to the lakes for a time before heading for Norfolk, so why not join them? The note finishes with the suggestion that Tom Dudgeon and the Death and Glories would be visiting the lake as well.

Ransome wrote a draft of the first four chapters of *The Death and Glories* followed by various notes and draft episodes for the remainder. The story starts outside Jonnatt's boatshed where the *Death and Glory* is tied up because there is no room beside the staithe. It is August and the height of the boat-letting season. Tom Dudgeon is on holiday with his parents and the twins are off somewhere with their father. There is deep gloom aboard, for salvage is no longer what it was. The boys considered themselves fortunate if they had so much as a 'thank you' when they got people out of trouble. The *Death and Glory* is much the same as she was the year before, still with the original green-painted chimney pot on the cabin roof but now she carries a row of old tyres as a protection against the inevitable collisions.

They decide to shift the *Death and Glory* to a safer mooring in the wilderness, returning to watch the cruiser the Jonnatt's have been building put onto an enormous lorry. They have a particular interest in the cruiser because they know that it is going to 'the lake in the north' where the Ds are on holiday. Ransome describes the delicate manoeuvring of the cruiser onto the back of the lorry and Mrs Barrable happens to remark, 'Pity you can't make the voyage on her.'

The lorry has to wait at the boatyard until the roads are clear before setting out for an all-night journey north. Joe, who has been thinking hard ever since Mrs Barrable's chance remark, insists they each have a large meal before they return to the village to watch the departure, and he manages to trick Bill and Pete into climbing aboard and stowing away...

After this promising beginning, there are various false starts. Somehow, the Death and Glories are left behind as the cruiser nears the lake, and they have to find their own way to Rio Bay where they are befriended by the cruiser's owner. They meet up

with the Swallows, Amazons and Ds in the middle of a capsizing party (like those the young Busks and Russells used to enjoy in the Walton Backwaters) and Joe, the former Bure pirate, meets Nancy Blackett, Amazon pirate.

Having all met up they are faced with the problem of how the Death and Glories are to return to Norfolk (Mrs Barrable seems to have remained in Horning) but nothing was resolved when Ransome abandoned the tale.

The Death and Glories draft, the notes and fragments were given the title *Coots in the North* by Hugh Brogan, who edited them for publication in 1988.

Although he continued to sail until he was seventy, there is no record of Ransome visiting the Broads after the war, which is perhaps surprising, until you consider that there could never be a return to those happy, carefree days when as 'Barnacle Bill' he had led the fleet of 'Northern River Pirates'.

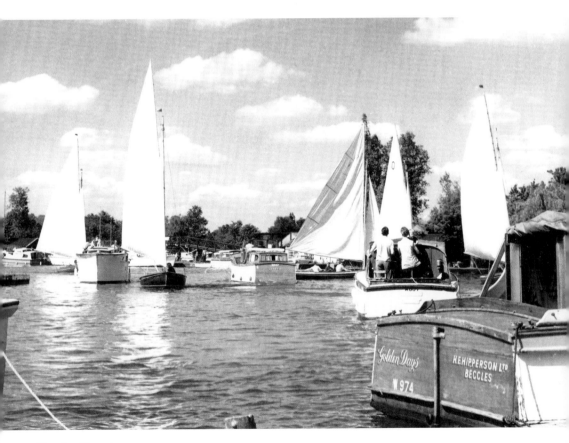

Horning Regatta
This popular August event was photographed in the 1960s.

Appendix
Broadland Craft
Real and Fictional

Cachalot
The design of the *Cachalot* was very much of its time, with a raised foredeck housing the cabin forward of a generous cockpit, and similar examples could be found in all parts of the country.

Come Along
It seems clear that the *Come Along* was based on the *Surprise* of 'Old Burbar' and a comparison between a photograph that Ransome took while under tow himself and the illustration 'The *Come Along* Says Come Along' supports this identification. The motor tug looks to be of typical Broads design, being a broad and shallow double-ender, rather like a large reed lighter.

Death and Glory
The *Death and Glory* was no more than some old ship's lifeboat at the time of *Coot Club*, but when writing *The Big Six* Ransome measured a lifeboat and from this information he carefully made scale drawings showing the Death and Glories aboard the conversion to a cabin boat on page 88.

Similar square cabins sitting on an old ship's boat can be seen in old photographs of eelmans' huts/hulks. The Yarmouth naturalist A. H. Patterson lived on such a craft.

Dreadnaught
Tom's black punt was of a simple double-ended design and similar craft were by no means uncommon at the time.

Fairway (Hire Yacht)
Jack Powles' ten *Fairway* class yachts were 23 feet long with a beam of 7 feet 6 inches and headroom with the lifting cabin top raised of 5 feet 11 inches. The two Primus stoves were housed in a special locker in the well, and because there were only three berths, there was space for a separate compartment for the washbasin and WC.

They were most attractive craft with their mahogany hulls and fittings of teak. After the war seven of the fleet had an auxiliary 1½ horsepower motor fitted and were renamed *Wanderbird*.

'Fine business wherry' see *Sir Garnet*

Flash

The Farland's *Flash* was clearly intended to be one of the Yare & Bure One-Design class of racing keelboats that were designed in 1908 by the prolific boatbuilder Ernest Woods, brother of the elder Walter Woods who set up the boat-hiring business in Potter Heigham.

The White Boats, as they are known, have become classics and are among the most beautiful craft on the Broads. They were raced by members of Horning Town Sailing Club from their headquarters at the Swan at the time of *Coot Club*, and Mr Farland must have been a leading member. Today the Horning Sailing Club has a fine clubhouse on the island on the bend of the river, and as many as sixteen White Boats lined up at the start for the weekly races last summer.

All White Boats are given names of butterflies or moths, so Ransome must have chosen the name *Flash* so as to avoid association with any particular craft, present or future. *Flash*'s rival, *Grizzled Skipper* (number fifty-six), did not exist in 1934 but was built four years later and is still racing at Horning.

These half-deckers are no sedate Edwardian ladies but are capable of giving an exhilarating sail in anything like a decent wind. Measuring 20 feet (plus a short bowsprit), with a beam of 6 foot 3 inches and a draft of 2 feet 9 inches with a sail area of 279 square feet, White Boats are still being built in GRP as their number approaches 140.

Grizzled Skipper see *Flash*

Norfolk Punt

The punt that Ransome carefully measured at Whiteslea was the development of a type popular with Victorian sportsmen who fixed a large shotgun to the top of the punt pointing forwards. Today there is a thriving Norfolk Punt Association who race regularly.

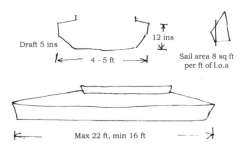

Draft 5 ins

12 ins

4 - 5 ft

Sail area 8 sq ft per ft of l.o.a

Max 22 ft, min 16 ft

Margoletta

Margoletta was probably intended to be a generic large cruiser of the type that had begun to appear in the boatyards during the previous ten years. Possibly Ransome had Jack Powles' Star class in mind.

Pudge see *Welcome*

Reed Lighter

Reed lighters were broad, double-ended open boats capable of remaining stable when loaded high with reeds. They were put to a number of uses and the drawing shows one being used as the Horning ferry after the pontoon was taken out of use at the time of the Second World War.

Royal Star (Hire Cruiser)

The Star class were large and well-appointed four-berth cruisers in the Jack Powles hire fleet. There were eight of them for hire in the 1947 catalogue, but there is no mention of the *Noble Star* that Evgenia referred to in her diary. Measuring 32 feet in length and with all-mahogany construction, these were striking-looking craft – rather like the *Margoletta*!

Sir Garnet

By the start of the twentieth century the fleet of 200 or more wherries had been greatly reduced. By the time of *Coot Club* there were less than a dozen still trading under sail and when *The Big Six* appeared there were none, except for a handful that had been converted to power or stripped of their gear and turned into lighters. Their bones could be seen up dykes, along Breydon flats and sunk in various broads, one or two of which had become veritable graveyards.

The trading wherry *Sir Garnet* took its name from Sir Garnet Wolseley, the inspiration for Gilbert and Sullivan's 'very model of a modern major general'. Ransome never mentioned the name of the 'fine business wherry' that passed them at Irstead, so no positive attribution is possible. It is tempting to believe that it was the *Lord Roberts*, since Sir Garnet Wolseley and Lord Roberts were contemporaries, and both served during the Indian Mutiny. At one time the *Lord Roberts* was painted red, white and blue instead of the traditional black hull and she continued to operate commercially under power into the 1960s.

Sir Garnet, 'the fastest wherry on the river', had few rivals. The *Hilda* that sank in a backwater behind Horning Ferry in 1939 is thought to have been the last wherry to trade commercially under sail.

Only two have survived into the twenty-first century, the *Albion*, a 40-tonner built in 1898 that traded under the auspices of the Norfolk Wherry Trust in the 1950s, and *Maud*, which was built the following year. Thanks to a herculean restoration project, after she had spent several years sunk in Ranworth Broad, *Maud* returned to the water in her centenary year.

Surprise see *Come Along*

Teasel

Certain craft in the canon did have 'exact originals', correct in every detail – *Swallow*, the *Goblin* and the *Scarab*, all of which Ransome owned, come to mind. There is no such identification possible with the *Teasel*. Ransome and Evgenia planned the interior layout of the four yachts that were built for them – *Racundra*, *Selina King*, *Peter Duck* and the second *Lottie Blossom* – and no doubt he enjoyed designing the *Teasel*. Having spent six weeks aboard the three-berth *Fairway* by the time that he came to illustrate *Coot Club*, it seems most likely that Ransome conceived *Teasel* as a four-berth *Fairway*. The wardrobe